THE S. MARK TAPER FOUNDATION

IMPRINT IN JEWISH STUDIES

BY THIS ENDOWMENT
THE S. MARK TAPER FOUNDATION SUPPORTS
THE APPRECIATION AND UNDERSTANDING
OF THE RICHNESS AND DIVERSITY OF
JEWISH LIFE AND CULTURE

The publisher gratefully acknowledges

the generous contribution toward the

publication of this book provided by

the S. Mark Taper Foundation

Children of a Vanished World

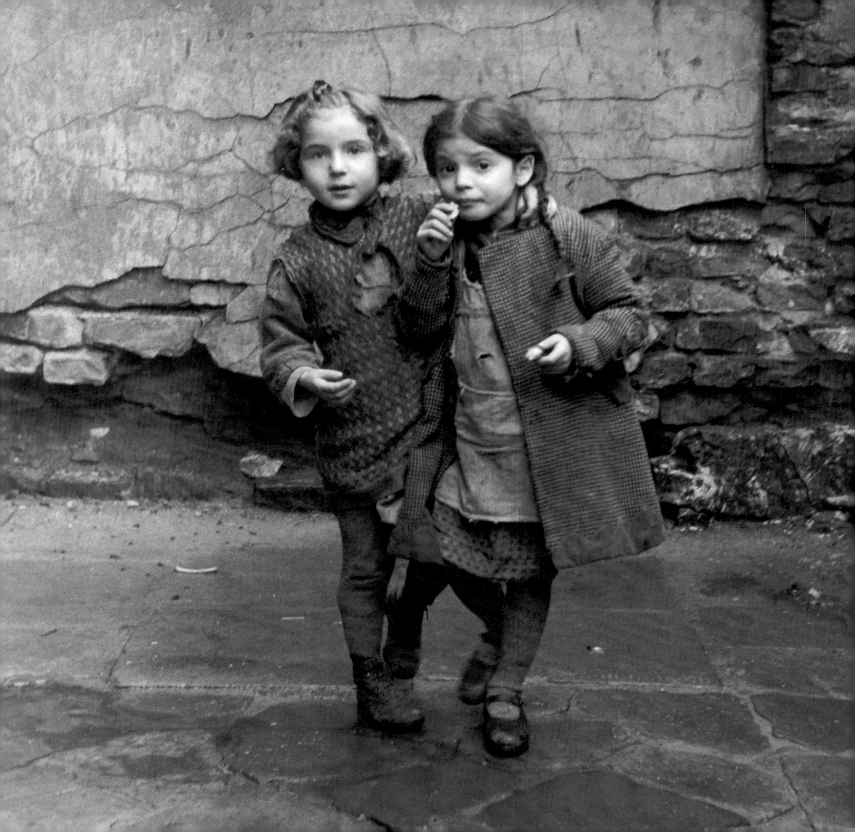

Roman Vishniac Children of a Vanished World

Edited by Mara Vishniac Kohn

and Miriam Hartman Flacks

University of California Press

Berkeley

Los Angeles

London

University of California Press
Berkeley and Los Angeles, California

University of California Press, Ltd.
London, England

The Yiddish texts and transliterations, as well as the music, for "Oyfn Pripetshik,"
"Rozhinkes mit Mandlen," "Yankele," "Hulyet, Kinderlekh," and "Motl" are reprinted
from *Mir Trogn A Gezang!* by Eleanor Gordon Mlotek with permission of The Center
for Cultural Jewish Life of The Workmen's Circle. The Yiddish texts and transliterations
on pages 82–100 are reprinted with permission from the YIVO Institute for Jewish
Research, from its publication *Yidishe folkslider mit melodyes,* compiled by I. L. Cahan,
edited by Max Weinreich, 1957; originally published in 1912.

Library of Congress Cataloging-in-Publication Data
Vishniac, Roman
 Children of a vanished world / Roman Vishniac ;
edited by Mara Vishniac Kohn and Miriam Hartman Flacks.
 p. cm. — (S. Mark Taper Foundation imprint in Jewish studies)
 Includes texts of Yiddish songs with English translations by Miriam Hartman Flacks.
 ISBN 0-520-22187-7
 1. Jewish children—Europe, Eastern Pictorial works. 2. Europe, Eastern Pictorial
works. 3. Jews—Europe, Eastern Pictorial works. I. Kohn, Mara Vishniac. II. Flacks,
Miriam Hartman. III. Title. IV. Series.
DS135.E8V56 1999
947' .0004924—dc21 99-27866
 CIP

Printed and bound in Italy
08 07 06 05 04 03 01 00 99
9 8 7 6 5 4 3 2 1

This book is dedicated, with love, to our grandchildren,

Ruby and Zina Goodall, Melina Schiff,

and Maurice and Olivia Flacks Klatch

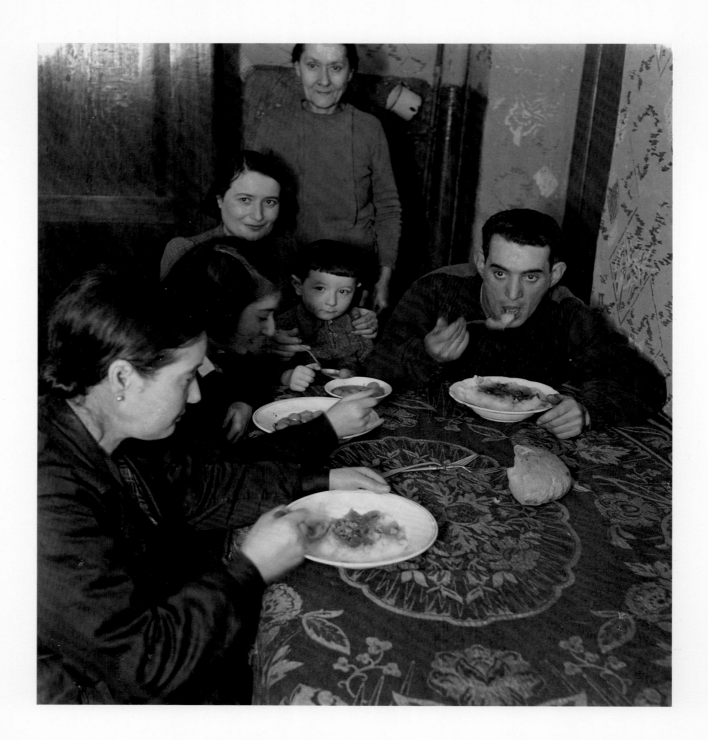

Contents

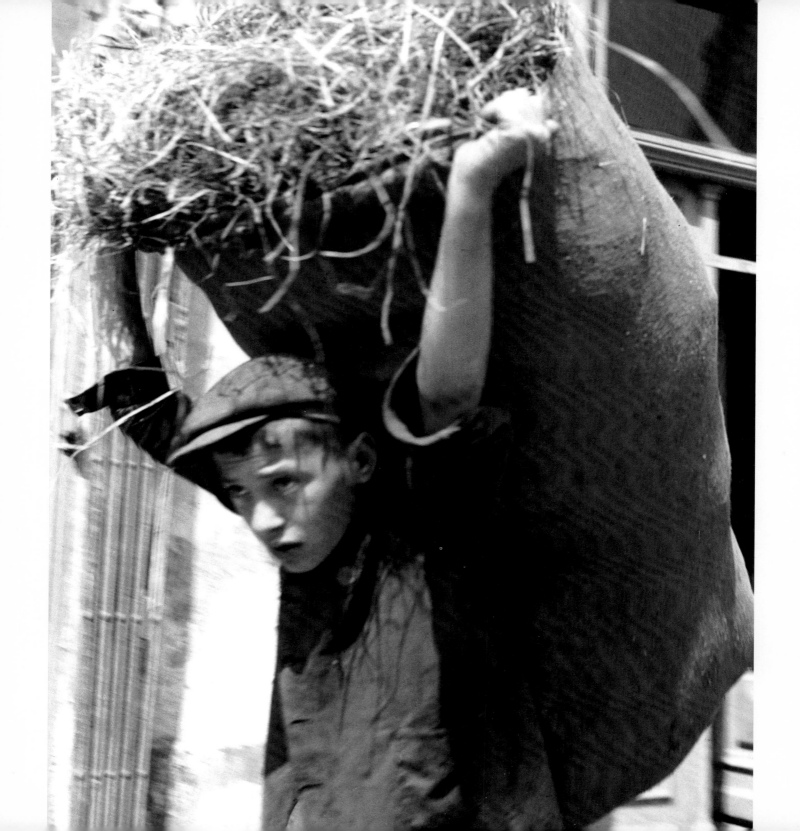

Introduction

My father, Roman Vishniac, took these pictures between 1935 and 1938 in traditional Jewish Eastern European villages and towns. It was a difficult time, with few options available to poor families trying to improve the circumstances of their lives. In an effort to help and support these poor communities' struggles to survive, the American Jewish Joint Distribution Committee in Central Europe organized a fund-raising drive. Joachim Prinz, the well-known and extremely popular Zionist rabbi in Berlin, advised the "Joint" to ask my father to take photographs to support their drive. "Roman," he told them, "is never seen without a camera; it's part of him and I think he'll do it." And so, Roman traveled east, as he thought, for one brief trip.

Once he arrived in Vilna, the "Jerusalem of Lithuania," he knew he had entered the world he had heard about as a child from his father and grandfather. This, he felt, was or had been his own family's life and therefore it was his. He began to make contacts, to photograph in the poorest sections of town, to listen to parents' burdens and fears, and to love the children.

When he returned to his darkroom in Berlin, I (aged nine) stood beside him in the red gloom and rocked ("Gently!" he said) the developer trays in which the images in this book first appeared. I discovered a life I had not known and asked many

questions. "Do these children have toys? Why does this boy carry such a large load on his back? Shouldn't he use a cart?" After two weeks of "our" work, I was told my father was ready for another trip. I asked, "For what?" "They are our people," my father said, "and we must help wherever we can."

He traveled east three or four times after that. They were arduous trips, in cold weather, with no assurance of the outcome. He was "handed" from one newfound friend to another. With the ultra-orthodox members of the community, he had to be mindful of the suspicion with which photographers and other "image-makers" were greeted. His notes describe how he enlarged a buttonhole in his winter coat so that the lens would fit through while the camera itself remained hidden. Depending on circumstances, he used either a Rolleiflex or a Leica, and he did all his work by available light, often loving the scene before him but not sure his film was sensitive enough to record it. For three years, Eastern Europe was his world; its Jewish communities, his; its children, his. Some of the images were used for the fund-raising drive. All began their existence by drying on the living room floor of our Berlin apartment. "Step carefully," I was told.

In Germany in the mid-1930s, no Jew could feel secure. Our Zionist youth groups were declared illegal; our "leaders" (aged eighteen or nineteen) were randomly arrested and questioned, usually to be freed after a few days. Telephone calls came for my parents with news of someone's arrest here, another's there. Economic and professional restrictions accumulated week by week. No one knew what would come next. The Jewish communities in Germany and its border states felt a pervasive dread and a darkness nearing.

What would happen to a Jewish photographer of Latvian nationality living in Berlin, who had surreptitiously taken thousands of pictures of struggling groups of East European Jews? My father felt certain that the poor he had visited in the *shtetlekh,* many of whom had become his dear friends, would not be able to survive. "I wanted," he said, "at least to save their faces." How could the negatives be saved? His father, Salomon Vishniac, was about to leave Berlin for Paris; he carried many of them with him.

The next difficulty was how to bring them out of Europe. Roman turned to a trusted friend who had been forced by the French to serve in the Foreign Legion in North Africa, but who now had returned to Marseilles, where Roman met him. Would the friend, Walter Bierer, consider carrying the negatives with him when he was able to leave Europe? The friend took the negatives and promised he would try. Roman returned to Paris and, within days, was arrested and interned in Camp Du Ruchard, a detention camp near Gurs.

In May 1939 I had been sent to safety in Sweden, where my mother and brother were finally able to join me, after being arrested in Latvia. It was my mother's task to persist in her efforts to obtain a U.S. visa and an affidavit of support from an American citizen, which would help to secure my father's release. On October 16, 1940, he wrote to us in Sweden, "Now my world is surrounded by barbed wire. I'm very cold and hungry. I wrote to a friend in Poland and asked him to send me a blanket, but I have received no answer." Finally, at the end of November 1940, after all my mother's work, a visa was granted and my father was released. Our family was able to reunite in Lisbon, where we awaited passage to the United States and safety.

The fate of Roman's negatives was more complicated. Walter Bierer carried them with him to Cuba, where he was interned for six months. With great difficulty and the help of his family already in the United States, he finally obtained an American visa, allowing him and the thousands of negatives to arrive in Miami. There the negatives were confiscated by U.S. Customs officers, but they were later released to my father in New York.

Roman tried to exhibit his images of impoverished Eastern European Jews on the brink of destruction. If any of these families were to be saved, there was no time to lose. He arranged for a small show at the Teachers College of Columbia University and wrote a letter to Eleanor Roosevelt, inviting her to visit the exhibition. An answer came from the White House: Mrs. Roosevelt regrets that she is unable to visit New York to see the pictures of Polish Jews. Roman knew that time was running out for the children he had come to love. He sent a selection of prints to FDR; the White House graciously thanked him for "the excellent pictures you sent to the President." That was all.

In this book, more than fifty years later, we want to remember the children Roman loved, the children of "a vanished world." Their images are surrounded with the songs and rhymes that made them smile. We want to look into their eyes and see there the wonder, the hope, and the trust in a future that they would not experience. We think of them, we assure them of our love, and we cherish their memory.

—Mara Vishniac Kohn

O Lord of Creation! Here there were people
Who lived and who worked, who sang and who cried!

Here, in joy they would bless, or curse in their fear,
Here merchants and customers bargained and vied,
Here they knitted and shouted, they danced and they leaped,
Here children were rocked in their cradles to sleep,
Here children were nestled to mothers' warm breasts . . .

— from "Shades of the Warsaw Ghetto," by Itzik Feffer,
a Soviet-Yiddish poet, executed with other Yiddish writers
in August 1952 (translated by Miriam Hartman Flacks)

The people "who lived and who worked, who sang and who cried" in Warsaw and the other areas of Jewish settlement in Eastern Europe in the nineteenth and twentieth centuries spoke Yiddish. The daily commerce of their lives—their arguing, debating, cooking, buying, selling, working, lovemaking, childrearing, writing, teaching, learning, even praying—was in Yiddish, a language they called *mame-loshn* ("mother tongue"). This language developed as truly a "folk" language and was for many years disparaged as "jargon," with no codified rules of grammar or spelling and little or no written literature. Yet it emerged as a vessel holding the cultural outpourings of the Jews of primarily Poland and

the Russian empire, as a manifestation of their national and cultural identity in the latter half of the nineteenth century. In addition to a prominent world-stage literature by such giants as Isaac Loeb Peretz, Sholem Aleichem, and Nobelist Isaac Bashevis Singer, hundreds of lesser-known novelists, essayists, poets, playwrights, and lyricists wrote in Yiddish in post-Enlightenment Eastern Europe and, later, in the United States.

A *mame-loshn* is, of course, the language of children, who usually have their own version of the language surrounding them. Whether in street rhymes, games, nursery rhymes, lullabies, stories, or folktales, a children's idiom emerges. This idiom is not always known to the scholars and "experts." In 1904 Regina Lilienthal, a psychologist, wrote in *The Jewish Child:*

> *Jewish children have few unique games, and none accompanied by song. This is characteristic, and I believe that their games are for counting purposes and are mostly at-home games. The former is the result of the occupation of the Jewish masses, and is an unconscious, practical part of child-training; the reason for the latter lies in the sad fate of the Jewish people: the constant fear of the danger that lies outdoors, the narrow ghetto walls lay like a heavy stone on the spiritual life of the Jewish child. Frightened and insecure, he was most comfortable in his own home, and his imagination flowered here. The children's games are as quiet and calm as they are themselves, and even in their group games no noise, no shrieking is heard. The expressions of joy and laughter have been stifled and suffocated in the Jewish child.*

To which Shmuel Zeinvil Pipeh, writing in the August–December 1936 issue of *YIVO Bletter* ("YIVO Pages"), replied:

For us, these words are comically absurd, because we have before us our games, so full of movement and laughter. Acquaintance with our material clearly shows that, although they have a uniquely Jewish cast, our children's games possess the same evidence of the child's psyche that is evident in children's folklore of other peoples.

The rhymes and songs presented in this volume, accompanying Roman Vishniac's photographs of the children who knew them, have often been collected during the past ninety years or so. They made their way to America along with the throngs of Yiddish-speaking immigrants who built new homes and lives in American cities. Even I, born in Brooklyn, New York, learned many of them as *mame-loshn,* at my mother's knee. Some were collected in books and magazines that have survived in the library of the YIVO Institute for Jewish Research in New York; some are nonsensical, some are works of profound poets, some are simply charming, some offer insight into the lives of Jewish children in pre-Holocaust Eastern Europe.

For today's non-Yiddish readers, we offer translations along with the original Yiddish texts, but we also provide transliterations to make it possible for a new generation, with different mother tongues, to pronounce the Yiddish words. To have a real sense of the lives of the children in this book, one must hear the Yiddish words they spoke and sang.

—Miriam Hartman Flacks

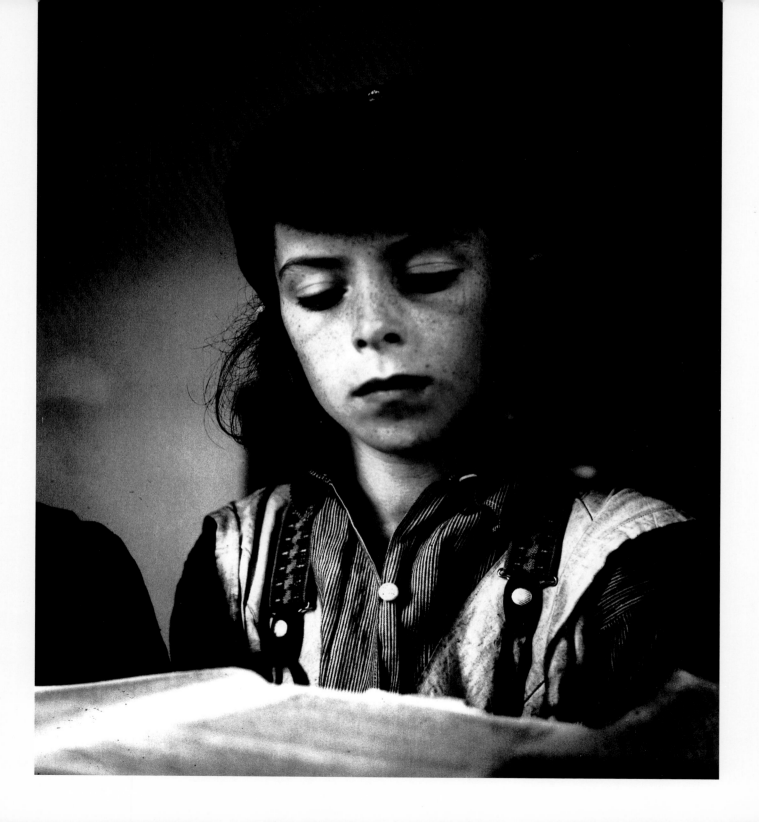

Children of a Vanished World

Bulbes	Potatoes

זונטיק — בולבעס,
Zuntik, bulbes

מאָנטיק — בולבעס,
Montik, bulbes

דינסטיק און מיטוואָך — בולבעס,
Dinstik un mitvokh, bulbes

דאָנערשטיק און פֿרײַטיק — בולבעס,
Donershtik un fraytik, bulbes

שבת אין אַ נאָוװענע — אַ בולבע-קוגעלע,
Shabes in a novene, a bulbe kugele

זונטיק — ווײַטער בולבעס!
Zuntik, vayter bulbes.

Sunday — potatoes,

Monday — potatoes,

Tuesday and Wednesday — potatoes,

Thursday and Friday — potatoes,

The Sabbath brings a novelty — potato *kugl!*

Sunday, once more potatoes . . .

(music on page 104)

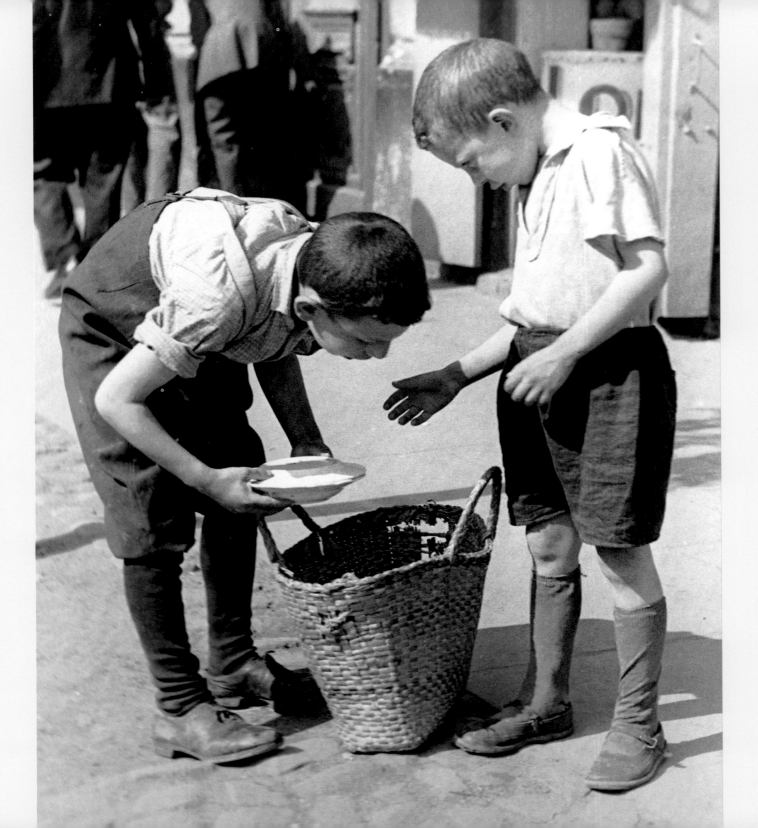

Bin Ikh Mir a Shnayderl

I Am a Little Tailor

בין איך מיר אַ שנײַדערל,
Bin ikh mir a shnayderl,

A little tailor, that is what I am,

בין איך מיר אַ שנײַדערל,
Bin ikh mir a shnayderl,

A little tailor, that is what I am,

לעב איך מיר טאָג־אויס־טאָג־אײַן
Leb ikh mir tog-oys-tog-ayn

And I live here every day

לוסטיק, פֿריילעך, פֿײַן.
Lustik, freylekh, fayn.

Happy, fine, and gay.

— זאָג מיר, שנײַדערל,
Zog mir, shnayderl,

Tell me, tailor,

ליבינקער און גוטער,
Libinker un guter,

as you pull your thread:

גיט דיר די נאָדל גענוג
Git dir di nodl genug

Does your needle earn you

אויף ברויט מיט פּוטער?
Oyf broyt mit puter?

the butter on your bread?

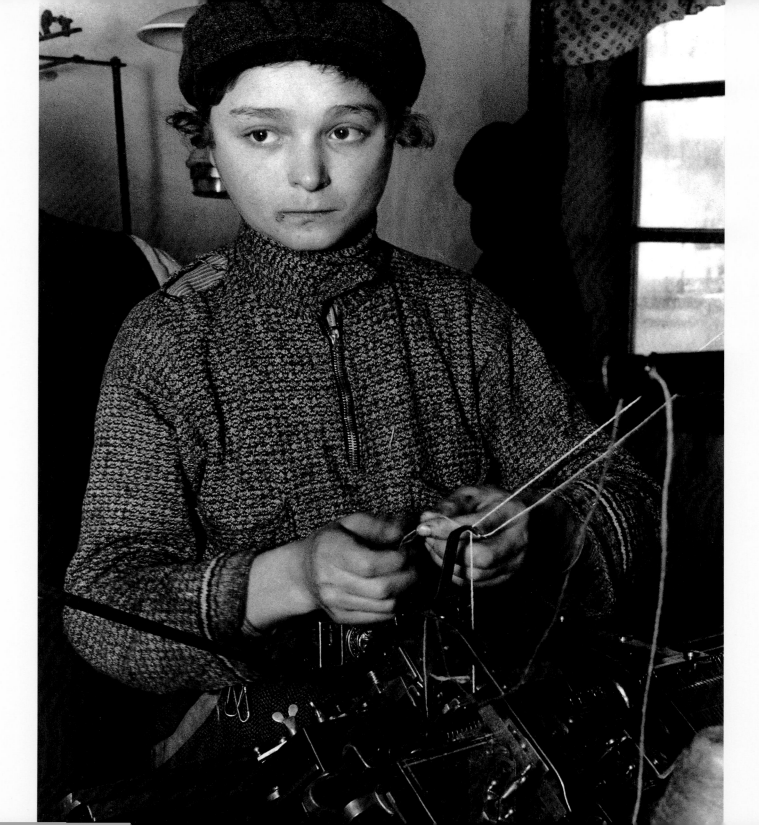

אִיך מַאך אַ װאך
Ikh makh a vokh

I make each week

צװײ גילדן מיט אַ דרײַער,
Tsvey gildn mit a drayer,

two nothings and a quarter.

אִיך עס נאָר ברױט,
Ikh es nor broyt,

I eat just bread;

װײַל פּוטער איז צו טײַער.
Vayl puter iz tsu tayer.

I can afford no butter.

בין איך מיר אַ שוסטערל,
Bin ikh mir a shusterl,

A little cobbler, that is what I am,

בין איך מיר אַ שוסטערל,
Bin ikh mir a shusterl,

A little cobbler, that is what I am,

לעב איך מיר טאָג־אױס־טאָג־אײַן
Leb ikh mir tog-oys-tog-ayn

And I live here every day

לוסטיק, פֿרײלעק, פֿײַן.
Lustik, freylekh, fayn.

Happy, fine, and gay.

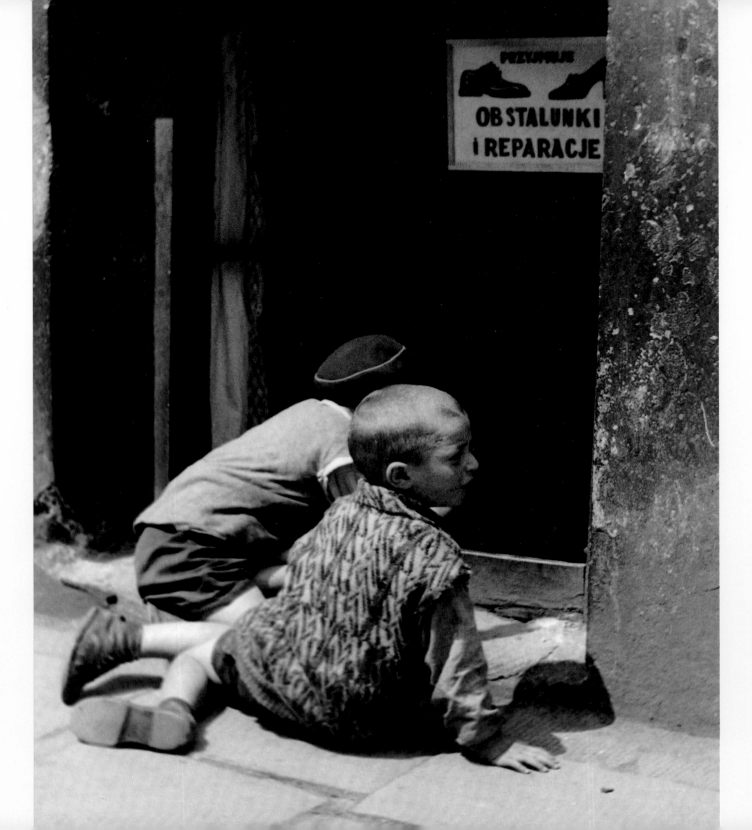

— זאָג מיר, שוסטערל,
Zog mir, shusterl,

האָסטו וואָס צו קײַען?
Hostu vos tsu kayen?

— פֿעלט דיר אויסעט
Felt dir oyset

האָסטו וואו צו לײַען?
Hostu vu tsu layen?

Tell me, cobbler,

Have you enough to eat?

Can you borrow

To buy the things you need?

— קיינער לײַט ניט,
Keyner layt nit,

קיינער גיט קיין ערבות.
Keyner git keyn orves.

איך בין אַ שוסטער,
Ikh bin a shuster,

גיי איך טאַקע באָרוועס.
Gey ikh take borves.

I have no money,

I have no funds for spending.

I am a cobbler,

my children's shoes need mending.

(music on page 106)

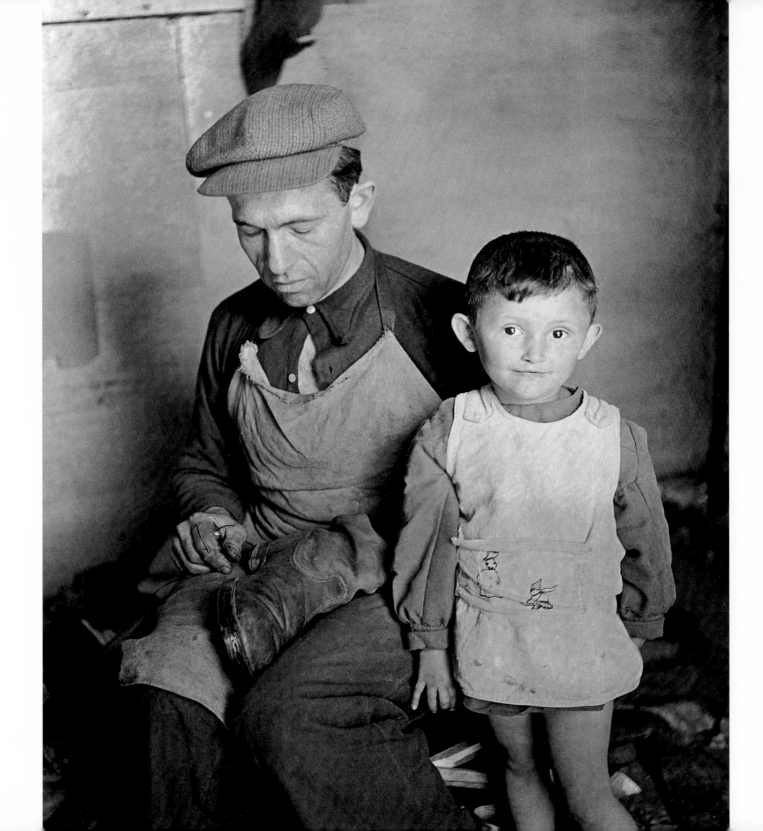

Patsh Zhe Kikhelekh

Clap Your Little Hands

פּאַטש זשע, פּאַטש זשע קיכעלעך,
Patsh zhe, patsh zhe kikhelekh

Clap, clap your little hands

דער טאַטע וועט קויפֿן שיכעלעך,
Der Tate vet koyfn shikhelekh

Dad will buy you little shoes

די מאַמע וועט שטריקן זעקעלעך,
Di Mame vet shtrikn zekelekh

Mom will knit you little socks

אַ געזונט אין יאַנקעלעס בעקעלעך!
A gezunt in (child's name) bekelekh!

And you (child's name) have such lovely cheeks!

(with the last line, lightly tap child's cheeks
with both hands and use child's name)

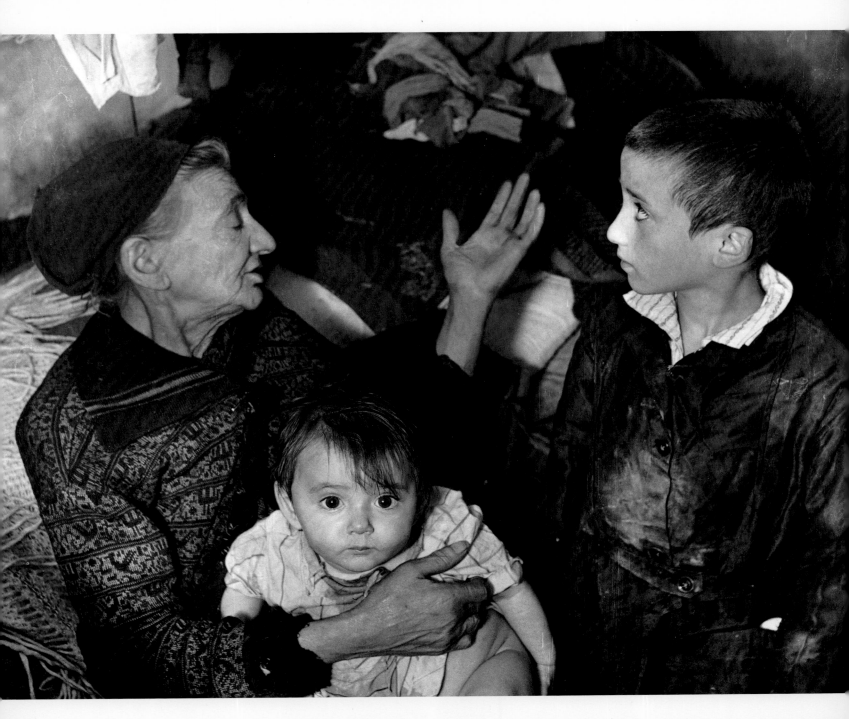

Oy, Mayn Kepele

Oy, My Little Head

אוי, מײַן קעפּעלע טוט מיר וויי,
Oy mayn kepele tut mir vey,

Oy, my little head, how it hurts,

אוי, מײַן קעפּעלע טוט מיר וויי,
Oy mayn kepele tut mir vey,

Oy, my little head, how it hurts,

אוי, מײַן קעפּעלע דרייט זיך ווי אַן עפּעלע,
Oy mayn kepele, dreyt zikh vi an epele,

Oy, my little head, guess I should have stayed in bed,

אוי, מײַן קעפּעלע טוט מיר וויי.
Oy mayn kepele tut mir vey.

Oy, my little head, how it hurts.

אוי, מײַן פֿיסעלע טוט מיר וויי,
Oy mayn fisele tut mir vey,

Oy, my little foot, how it hurts,

אוי, מײַן פֿיסעלע טוט מיר וויי,
Oy mayn fisele tut mir vey,

Oy, my little foot, how it hurts,

אוי, מײַן פֿיסעלע גייט נאָר אַ ביסעלע,
Oy mayn fisele, geyt nor a bisele,

Oy, my little foot, I can't even wear a boot,

אוי, מײַן פֿיסעלע טוט מיר וויי.
Oy mayn fisele tut mir vey.

Oy, my little foot, how it hurts.

(music on page 108)

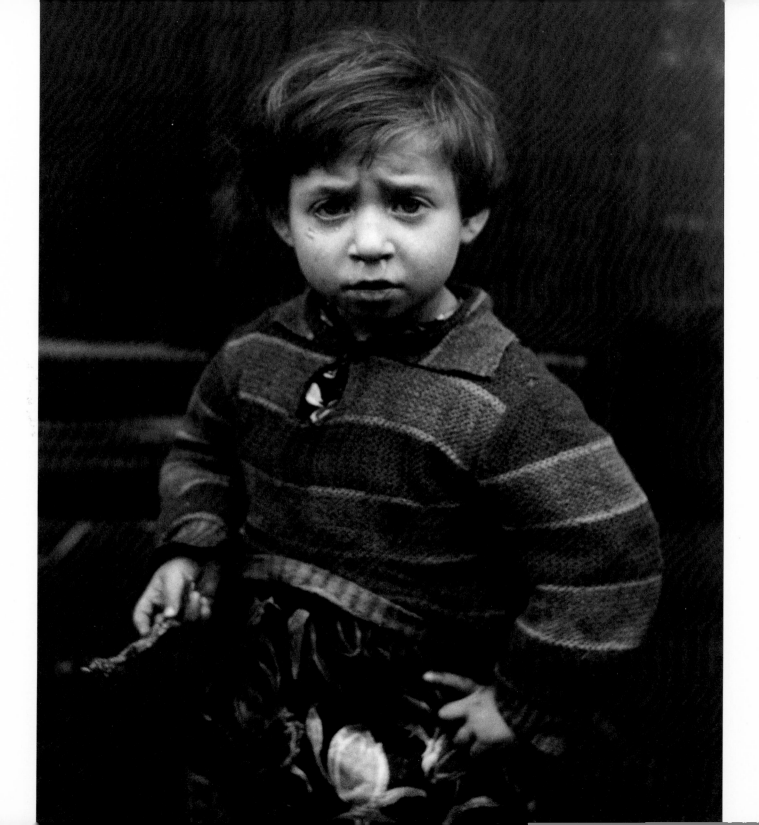

Oyfn Pripetshik

On the Oven's Hearth

אויפֿן פּריפּעטשיק ברענט אַ פֿײַערל,
Oyfn pripetshik brent a fayerl,

On the oven's hearth a little fire burns

און אין שטוב איז הייס.
Un in shtub iz heys.

Oh, how hot it gets.

און דער רבי לערנט קליינע קינדערלעך
Un der rebe lernt kleyne kinderlekh

Here the *rebe* teaches all the little ones

דעם אַלף־בית.
Dem alef-beys.

Our alphabet:

Chorus:

זעט זשע, קינדערלעך, געדענקט זשע טײַערע,
Zet zhe kinderlekh, gedenkt zhe, tayere,

"Here, my little ones, remember for all time

וואָס איר לערנט דאָ,
Vos ir lernt do,

Say it without flaw:

זאָגט זשע נאָך אַ מאָל און טאַקע נאָך אַ מאָל:
Zogt zhe nokh a mol un take nokh a mol:

Say it once again, repeat it yet again,

קמץ־אַלף: אָ.
Komets alef: "o."

Komets-alef— 'aw.'"

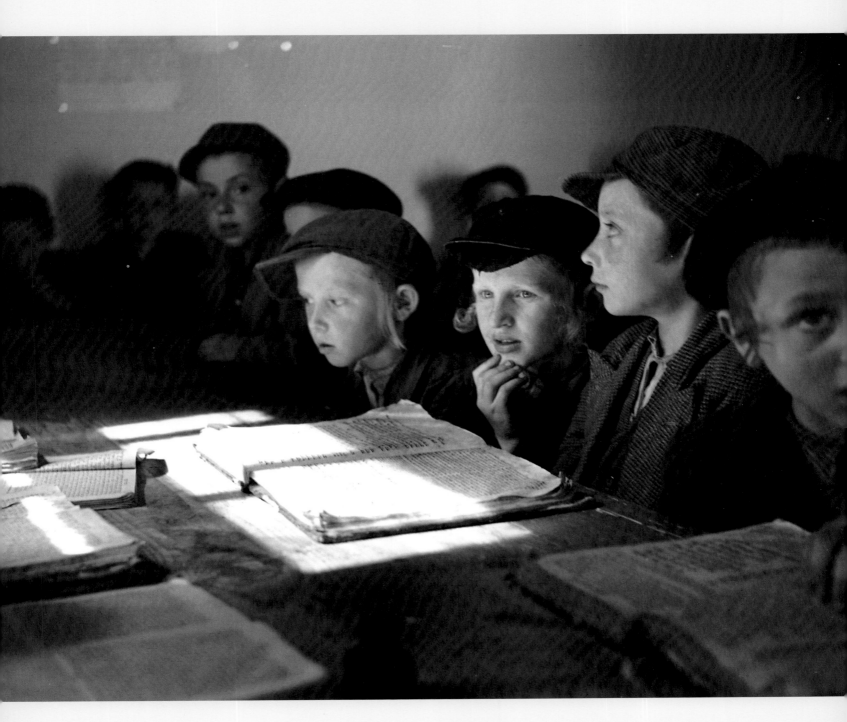

לערנט, קינדער, מיט גרויס חשק,
Lernt, kinder, mit groys kheyshek,

אזוי זאָג איך אײַך אָן,
Azoy zog ikh aykh on,

ווער ס׳וועט גיכער פֿון אײַך קענען עבֿרי,
Ver s'vet gikher fun aykh kenen ivre,

דער באַקומט אַ פֿאָן.
Der bakumt a fon.

אַז איר וועט, קינדערלעך, עלטער ווערן,
Az ir vet, kinderlekh, elter vern,

וועט איר אַליין פֿאַרשטיין,
Vet ir aleyn farshteyn,

וויפֿל אין די אותיות ליגן טרערן,
Vifl in di oysyes lign trern,

און ווי פֿיל געוויין.
Un vi fil geveyn.

Learn, my little ones, with a passion, learn

With fire in your eyes;

Whoever learns the Hebrew faster than the rest,

He will get a prize.

(Chorus)

As you, my dearest ones, will grow up a bit,

You yourselves will know

How the letters of our ancient alphabet

Carry so much woe.

(Chorus)

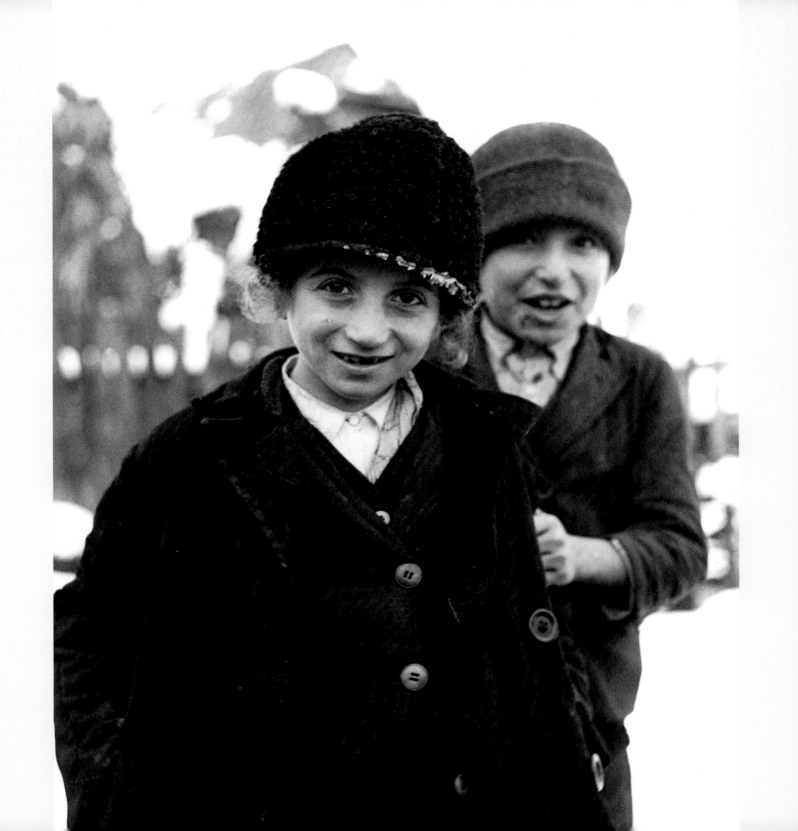

אַז איר וועט, קינדערלעך, דעם גלות שלעפּן,
Az ir vet, kinderlekh, dem goles shlepn,

אויסגעמוטשעט זײַן,
Oysgemutshet zayn,

זאָלט איר פֿון די אותיות כּוח שעפּן,
Zolt ir fun di oysyes koyekh shepn,

קוקט אין זיי אַרײַן!
Kukt in zey arayn!

When you, my dearest ones, in foreign exile dwell,

Wearied, brought low down,

From these letters, then, you will draw strength;

Here comfort can be found.

(Chorus)

(music on page 110)

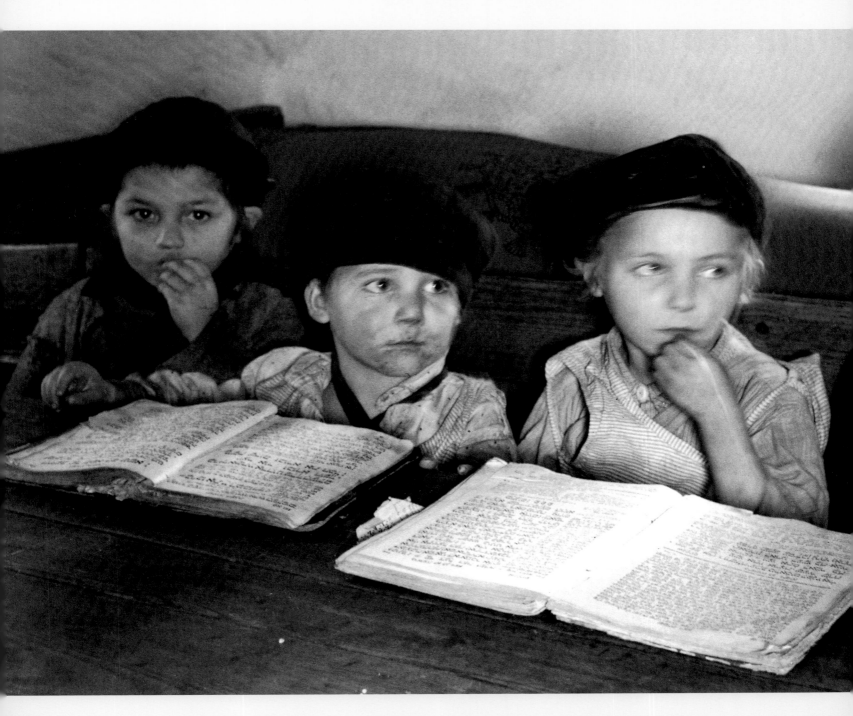

Yankele

Yankele

שלאָף זשע מיר שוין, יאַנקעלע, מיַין שיינער,
Shlof zhe mir shoyn, Yankele, mayn sheyner,

די אייגעלעך, די שוואַרצינקע, מאַך צו;
Di eygelekh di shvartsinke, makh tsu;

אַ ייִנגעלע, וואָס האָט שוין אַלע ציינדעלעך
A yingele vos hot shoyn ale tseyndelekh

מוז נאָך די מאַמע זינגען איַי-ליו-ליו?
Muz nokh di mame zingen ay-lyu-lyu?

אַ ייִנגעלע, וואָס האָט שוין אַלע ציינדעלעך,
A yingele vos hot shoyn ale tseyndelekh,

און וועט מיט מזל באַלד אין חדר גיין,
Un vet mit mazl bald in kheyder geyn,

און לערנען וועט ער חומש און גמרא,
Un lernen vet er khumesh un gemore,

זאָל וויינען ווען די מאַמע וויגט אים איַין?
Zol veynen ven di mame vigt im ayn?

Sleep then now, my Yankele, my darling,

For now's the time to close your lovely eyes;

A little boy, already finished teething,

He still needs me to sing him lullabies?

A little boy, already finished teething,

Who'll soon, God willing, to the *kheyder* go

To study all the Torah and the Talmud,

Should not he sleep and not be fussing so?

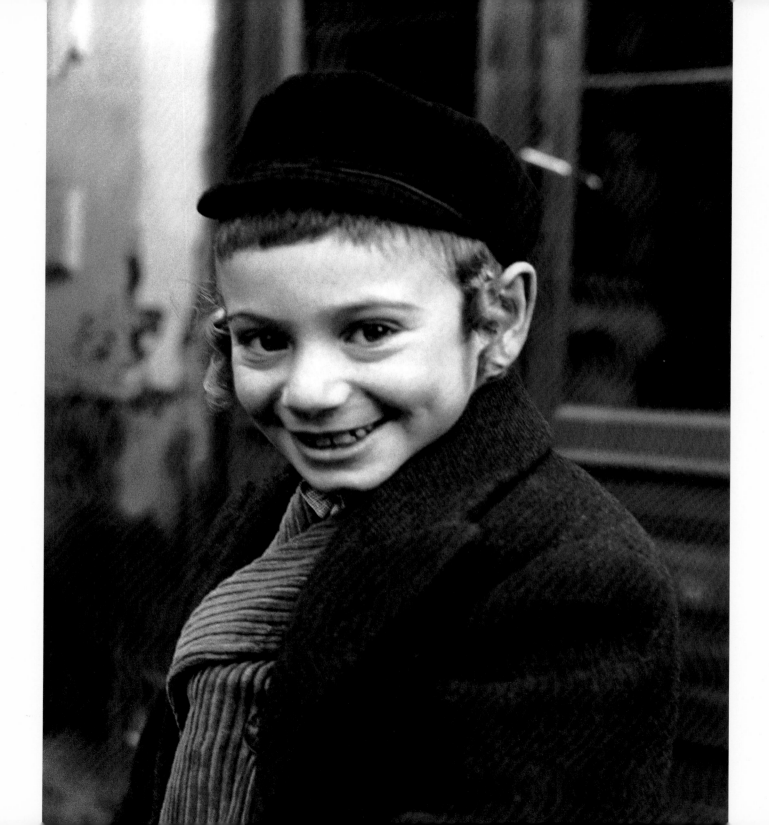

אַ ייִנגעלע וואָס לערנען וועט גמרא,

A yingele vos lernen vet gemore,

אָט שטייט דער טאַטע, קוועלט און הערט זיך צו,

Ot shteyt der tate, kvelt un hert zikh tsu,

אַ ייִנגעלע, וואָס וואַקסט אַ תּלמיד־חכם,

A yingele vos vakst a talmed-khokhem,

לאָזט גאַנצע נעכט דער מאַמען ניט צו רו?

Lozt gantse nekht der mamen nit tsu ru?

אַ ייִנגעלע, וואָס וואַקסט אַ תּלמיד־חכם,

A yingele vos vakst a talmed-khokhem,

און אַ געניטער סוחר אויך צו גלײַך,

Un a geniter soykher oykh, tsu glaykh,

אַ ייִנגעלע, אַ קלוגער חתן־בוחר,

A yingele, a kluger khosn-bokher,

זאָל ליגן אַזוי נאַס ווי אין אַ טײַך?

Zol lign azoy nas vi in a taykh?

A little boy who'll study all the Torah,

Just look at how your father swells with pride,

A little boy, a budding Talmud scholar,

Should never let his mother sleep at night?

A little boy, a budding Talmud scholar,

And a successful merchant, too, I'll bet,

A little boy, a charming, clever bridegroom,

Should lie here in a puddle, soaking wet?

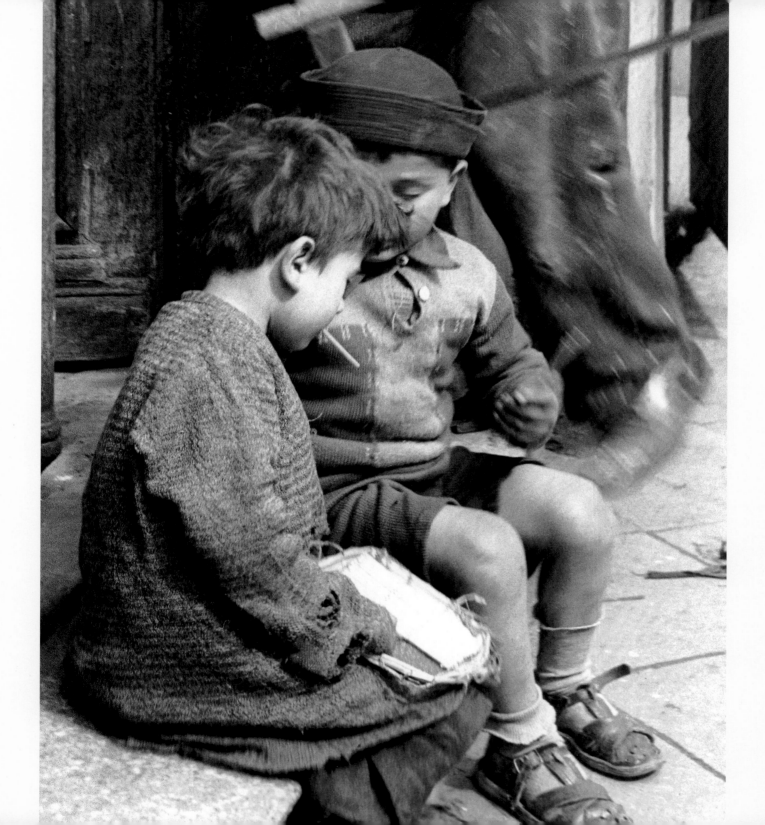

נו, שלאָף זשע מיר, מײַן קלוגער חתן־בוחר,

Nu, shlof zhe mir, mayn kluger khosn-bokher,

דערװײַל ליגסטו אין װיגעלע בײַ מיר.

Dervayl ligstu in vigele bay mir.

ס׳װעט קאָסטן נאָך פֿיל מי און מאַמעס טרערן

S'vet kostn nokh fil mi un mames trern

ביז װאָנען ס׳װעט אַ מענטש אַרױס פֿון דיר.

Biz vanen s'vet a mentsh aroys fun dir!

Nu, sleep for now, my charming, clever bridegroom,

Meanwhile you're in your cradle near my bench,

And it will take much work and mother's weeping

Until from you emerges a full *mentsh!*

(music on page 112)

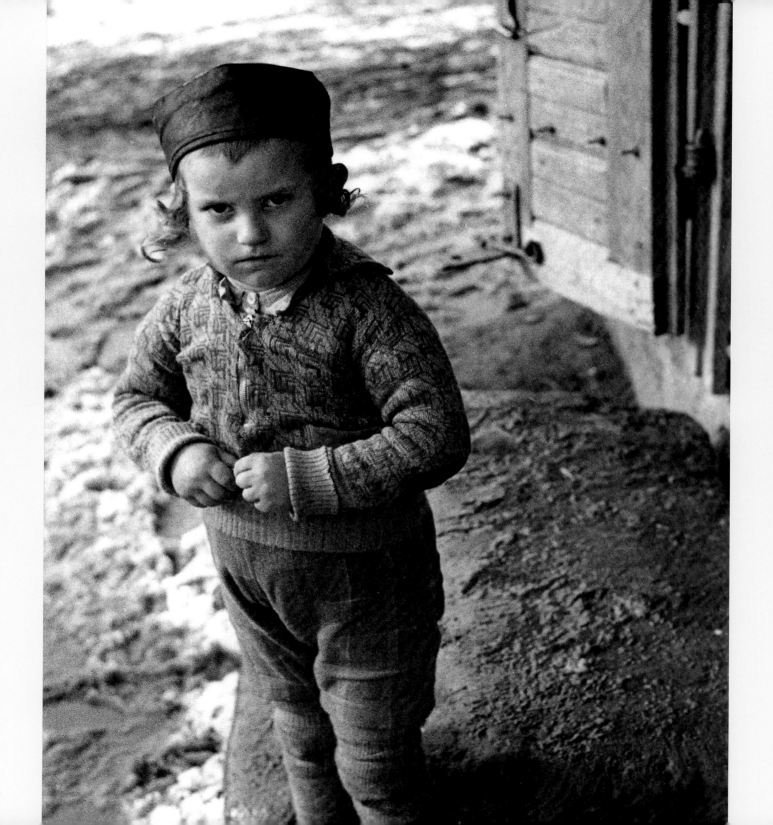

Motl

Motl

— וואָס וועט דער סוף זײַן, מאָטל, זאָג זשע מיר?
Vos vet der sof zayn, Motl, zog zhe mir?

ביסט ערגער נאָך פֿון פֿריִער געוואָרן,
Bist erger nokh fun frier gevorn,

באַקלאָגט האָט זיך דער רבי הײַנט אויף דיר,
Baklogt hot zikh der rebe haynt oyf dir,

אַז דו דערגייסט אים זײַנע יאָרן.
Az du dergeyst im zayne yorn.

ס׳איז נישט גענוג דו ווילסט ניט לערנען גאָר,
S'iz nisht genug du vilst nit lernen gor,

דעם רבין נעבעך טוסט דערצערנען,
Dem rebn nebekh tust dertsernen,

שלאָגסט זיך אַרום און שפּילסט זיך נאָר,
Shlogst zikh arum un shpilst zikh nor,

און שטערסט די קינדערלעך דאָס לערנען.
Un shterst di kinderlekh dos lernen.

What will the end be, Motl, do you know?

It's even worse now than before;

For just today the *rebe* let me know

That he can't stand it anymore.

It isn't just that you will not sit still,

You keep the *kheyder* classroom churning,

You fight and fool around at will

And keep the others from their learning.

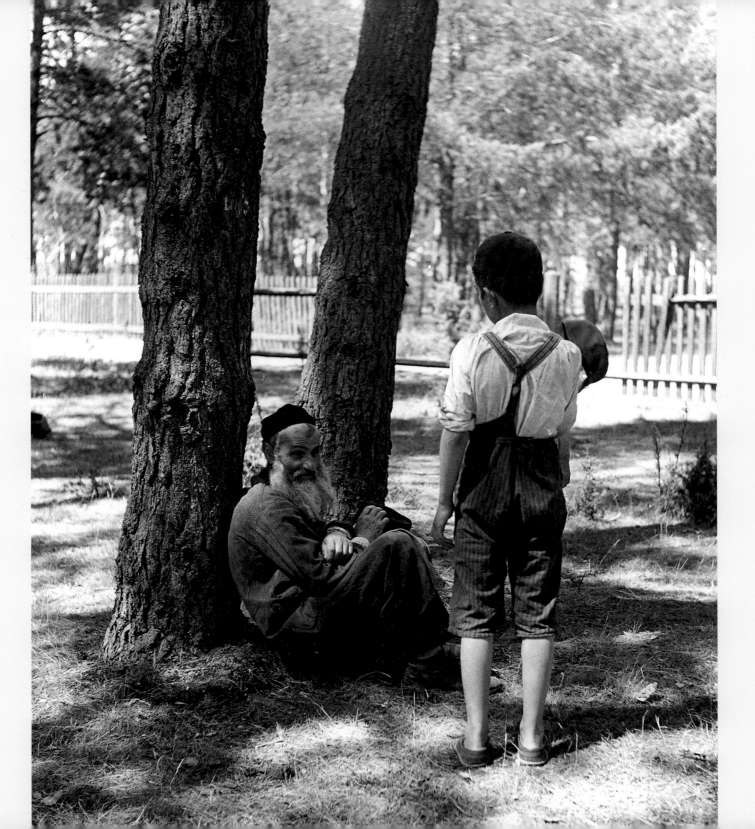

— נישט אמת, טאַטע, וואָס דער רבי זאָגט,
Nisht emes, tate, vos der rebe zogt,

אַ שלעכטער מענטש, נישטאָ זײַן גלײַכן,
A shlekhter mentsh, nishto zayn glaykhn;

פֿאַר וואָס דערצײַלט ער נישט, ווי ער אונדז שלאָגט,
Far vos dertseylt er nisht vi er undz shlogt,

זע, טאַטעניו, דעם בלאָען צײַכן.
Ze, tatenyu, dem bloen tseykhn.

כ׳האָב מיט אַבֿרהמלען זיך צעווערטלט בלויז,
Kh'ob mit Avremlen zikh tsevertlt bloyz,

ער האָט מײַן חומשל צעריסן,
Er hot mayn khumeshl tserisn,

דערפֿאַר האָט אונדז דער רבי אויף זײַן שויס
Derfar hot undz der rebe oyf zayn shoys

נאָך מיט אַ ניגונדל געשמיסן.
Nokh mit a nigndl geshmisn.

The rebe's tale, dear Dad, is not all true:

An evil man, and always cursing;

About the hitting he does not tell you,

The black-and-blue mark still is hurting.

My friend Avreml had a fight with me;

He grabbed my *khumesh,* it was ripping,

And just for that, the rebe took us on his knee,

And while he chanted, gave us a whipping.

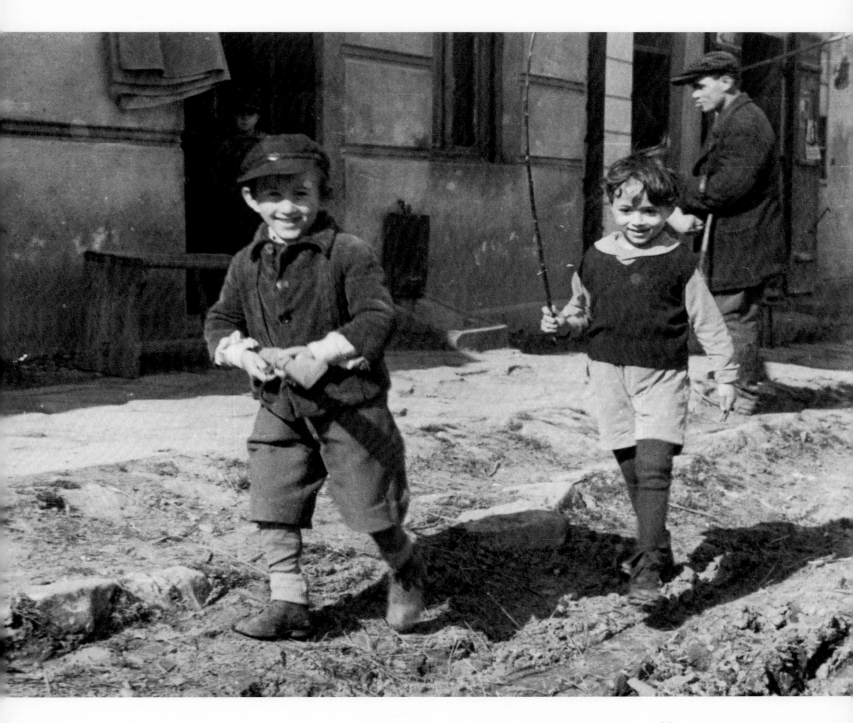

וואָס וועט דער סוף זײַן, מאָטל? ענטפֿער ד׳רויף —
Vos vet der sof zayn, Motl? Entfer d'royf:

די שכנים זאָגן, כ׳מוז זיי גלויבן,
Di skheynim zogn, kh'muz zey gloybn,

דו יאָגסט זיך גאַנצע טעג אַרום אין הויף,
Du yogst zikh gantse teg arum in hoyf

און חבֿרסט זיך מיט יאַנעקס טויבן, —
Un khaverst zikh mit Yaneks toybn;

צי איז דאָס שיין פֿאַר ייִדן, זאָג אַליין,
Tsi iz dos sheyn far yidn, zog aleyn,

מיט טויבן זיך אַרומצויאָגן?
Mit toybn zikh arumtsuyogn?

האָסט נעכטן, מאָטל, ווידער מיט אַ שטיין
Host nekhtn, Motl, vider mit a shteyn

דעם שכנס שויב אויסגעשלאָגן?
Dem shokhns shoybn oysgeshlogn.

What will the end be, Motl? Just you say;

The neighbors tell—they are not lying—

Of how with Yanek's pigeons, every day,

You chase around—like them, you're flying.

Now is that nice for Jewish fellows—just you say—

To chase the birds, drive them insane?

You, with a stone again, just yesterday,

Knocked out a neighbor's windowpane.

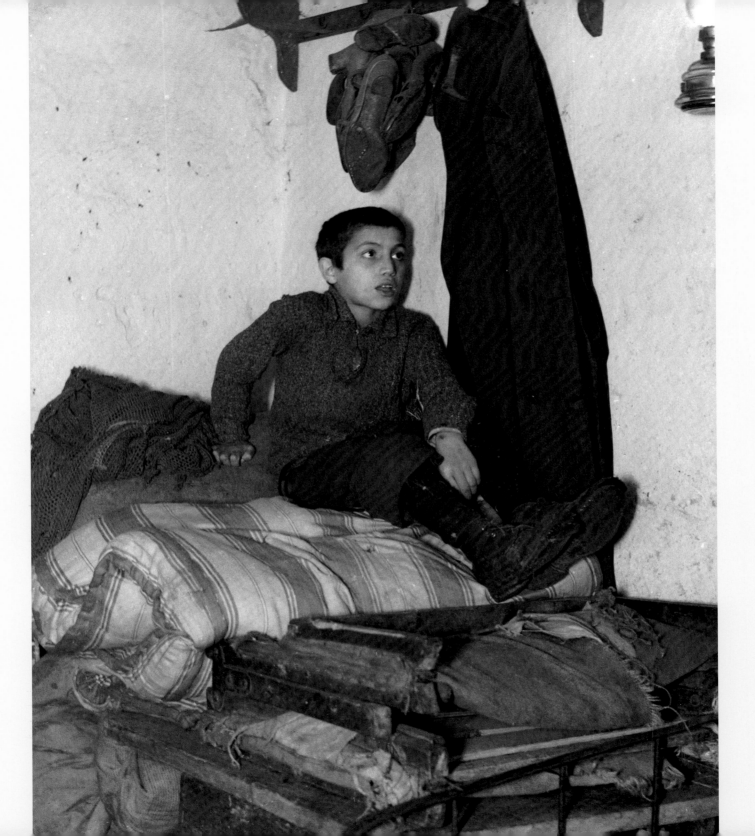

<div dir="rtl">

— נישט אמת, טאַטע, ס׳איז נאָר קוים אַרויס
Nisht emes, tate, s'iz nor koym aroys

אַ שטיקל שויב, מ׳קענס צוקלעפּן.
A shtikl shoyb, m'kens tsuklepn.

איך יאָג זיך נישט, איך קוק זיך צו נאָר בלויז,
Ikh yog zikh nisht, ikh kuk zikh tsu nor bloyz,

ווי שיין די טײַבעלעך זיך שוועבן,
Vi sheyn di taybelekh zikh shvebn,

ווי פֿרײַ זיי שפרינגען זיך אַרום אין הויף,
Vi fray zey shpringen zikh arum in hoyf,

ווי שיין די קערנדלעך זיי פּיקן,
Vi sheyn di kerndlekh zey pikn,

ווי שנעל זיי גיבן זיך אַ לאָז אַרויף,
Vi shnel zey gibn zikh a loz aroyf,

ווען זיי אַ פֿרעמדע טויב דערבליקן.
Ven zey a fremde toyb derblikn.

</div>

It is not true, dear Dad, it's hardly out,

It's just a piece, it can be mended.

I do not chase, I simply hang about

And watch the birds soar, as God intended.

How freely, happily they jump around

To find and peck the seeds and crumbs,

And how they are so quick to leave the ground

If a stranger among them comes.

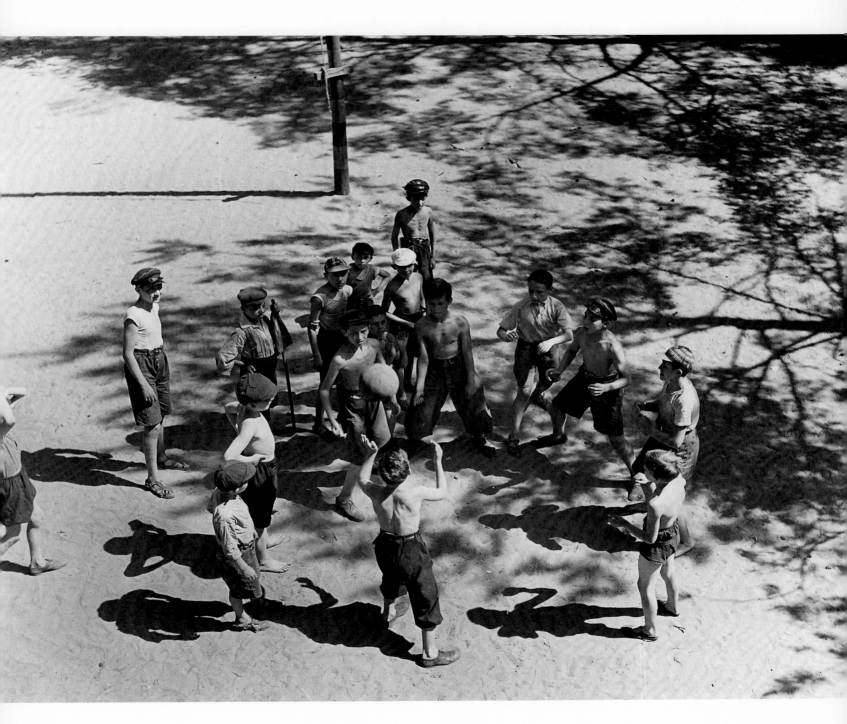

וואָס וועט דער סוף זײַן, מאָטל, כ׳פֿרעג דיך נאָר? —
Vos vet der sof zayn, Motl, kh'freg dikh nor?

אַ גרױסער יונג, קײן עין־הרע.
A groyser yung, keyn ayn-hore.

ווען איך בין אַלט געווען דרײַצן יאָר,
Ven ikh bin alt gevezn draytsn yor,

געקענט װי װאַסער די גמרא,
Gekent vi vaser di gemore.

אַ ייִד מוז לערנען תּורה מיט גרױס פֿרײד,
A yid muz lernen toyre mit groys freyd,

נישט האָבן נאַרישקײט אין זינען —
Nisht hobn narishkeyt in zinen—

אַז װאױל דעם מענטש, װאָס איז צו גאָט, צו לײַט,
Az voyl dem mentsh, vos iz tsu got, tsu layt,

װאָס קען גוט לערנען און געלט פֿאַרדינען.
Vos ken gut lernen un gelt fardinen.

What will the end be, Motl, I ask you?

A great big boy, *keyn ayn-hore;*

When I was just a boy like you

I was so fluent in *gemore.*

A Jew must study Torah all he can,

Not bother with what's light and foolish,

For praised be he who honors God and man,

Both earns a living and is studious.

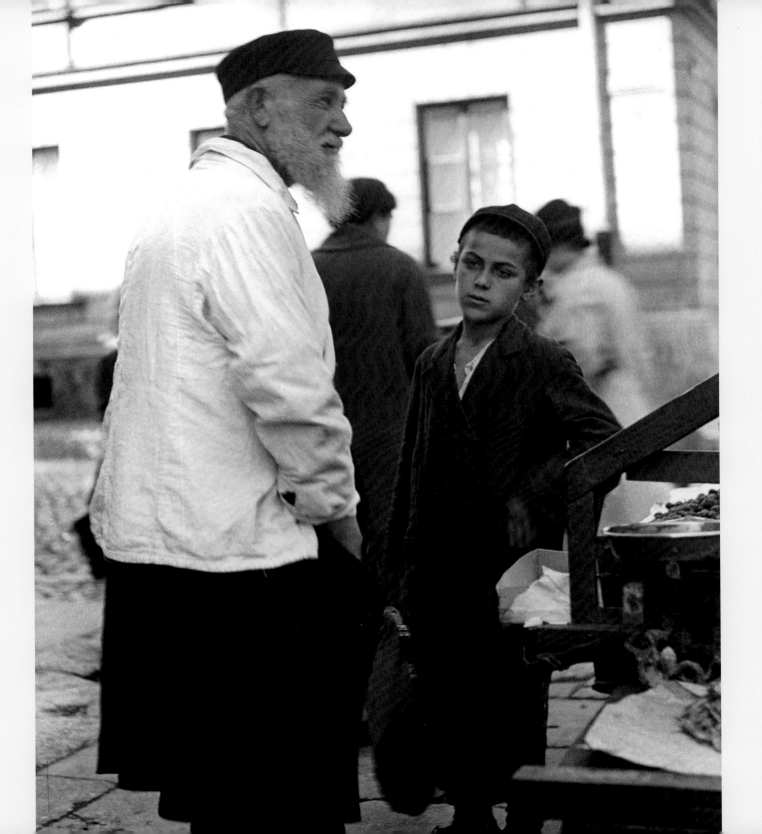

דער זיידע האָט אַ מאָל דערציילט פֿון דיר, —
Der zeyde hot amol dertseylt fun dir:

פֿלעגסט אויך נאָך טײַבעלעך זיך יאָגן,
Flegst oykh nokh taybelekh zikh yogn,

ביסט אויך פֿיל בעסער נישט געווען פֿון מיר,
Bist oykh fil beser nisht geven fun mir,

דײַן רבי האָט דיך אויך געשלאָגן,
Dayn rebe hot dikh oykh geshlogn,

הײַנט קענסטו לערנען און האָסט געלט דערצו,
Haynt kenstu lernen un host gelt dertsu,

האָב, טאַטעניו, פֿאַר מיר קיין מורא,
Hob, tatenyu, far mir keyn moyre,

ווען איך וועל ווערן גרויס, וועל איך, ווי דו,
Ven ikh vel vern groys, vel ikh, vi du,

פֿאַרדינען געלט און לערנען תּורה.
Fardinen gelt un lernen toyre.

My Grandpa told me all about you, Dad,

About the pigeons you were chasing

And all about the escapades you had —

Your rebe gave you quite a pasting.

Today, you study and have money, too;

About me, Dad, have no misgiving:

When I grow up, I will, like you,

Both study Torah and make a living.

(music on page 114)

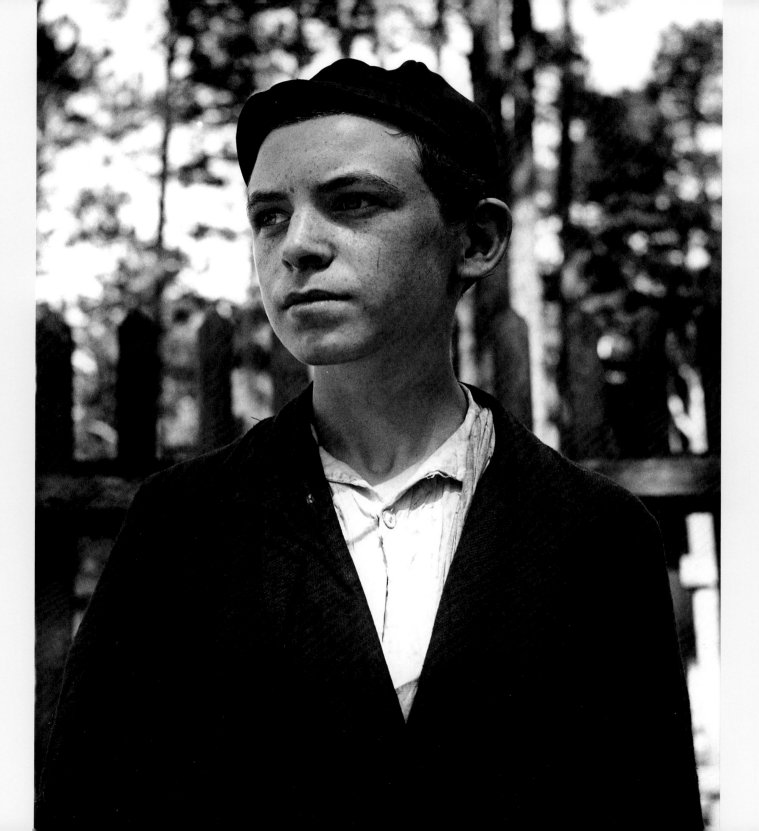

Hulyet, Kinderlekh

Revel, Little Ones

שפילט אײַך, ליבע קינדערלעך —
Shpilt aykh, libe kinderlekh—

Play on, dearest little ones,

דער פֿרילינג שוין באַגינט!
Der friling shoyn bagint!

For spring has come anew,

אוי ווי בין איך, קינדערלעך,
Oy, vi bin ikh, kinderlekh,

Oh, my dearest little ones,

מקנא אײַך אַצינד.
Mekane aykh atsind.

Oh, how I envy you.

Chorus:

הוליעט, הוליעט, קינדערלעך,
Hulyet, hulyet, kinderlekh,

Revel, revel, little ones,

כּל־זמן איר זענט יונג,
Kol-zman ir zent yung,

Now, while you're still young,

ווײַל פֿון פֿרילינג ביז צום ווינטער
Vayl fun friling biz tsum vinter

For from the springtime to the winter

איז אַ קאַצן־שפּרונג.
Iz a katsn shprung.

Is an eyeblink long.

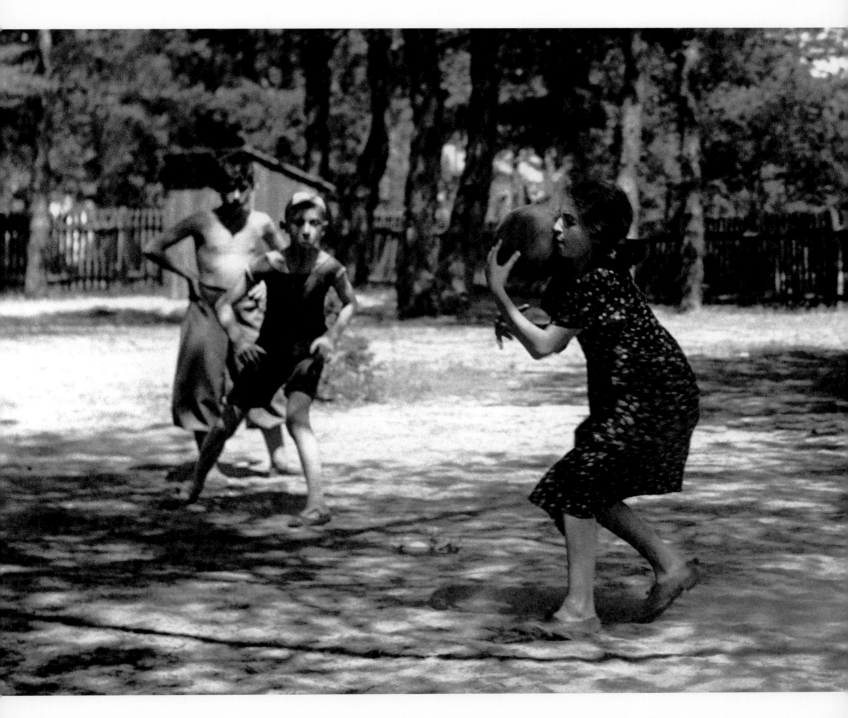

שפּילט אײַך, ליבע קינדערלעך,
Shpilt aykh, libe kinderlekh,

פֿאַרזוימט קיין אויגנבליק.
Farzoymt keyn oygnblik.

נעמט מיר אויך אַרײַן אין שפּיל,
Nemt mikh oykh arayn in shpil

פֿאַרגינט מיר אויך דאָס גליק.
Fargint mir oykh dos glik.

קוקט נישט אויף מײַן גראָען קאָפּ,
Kukt nisht oyf mayn groyen kop,

צי שטערט דאָס אײַך אין שפּיל?
Tsi shtert dos aykh in shpil?

מײַן נשמה איז נאָך יונג,
Mayn neshome iz nokh yung,

ווי צוריק מיט יאָרן פֿיל.
Vi tsurik mit yorn fil.

Play on, dearest little ones,

Do not waste the day;

Let me also share your joy,

Include me in your play.

(Chorus)

Do not stare at my old, gray head;

Does it disturb your play?

My soul, dear children, is still young

As in a former day.

(Chorus)

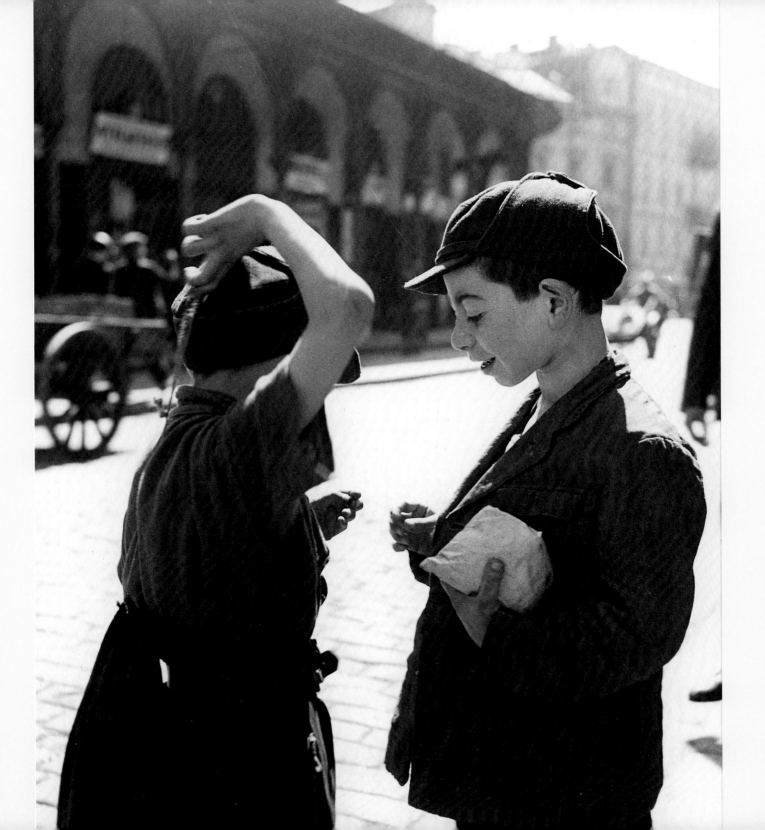

מײַן נשמה איז נאָך יונג,
Mayn neshome iz nokh yung

My soul, dear children, is still young

און גייט פֿון בענקשאַפֿט אויס.
Un geyt fun benkshaft oys.

And dies of loneliness.

אַך, ווי גערן ווילט זיך איר
Akh, vi gern vilt zikh ir

Ah, how much it wants to dance,

פֿון אַלטן גוף אַרויס.
Fun altn guf aroys.

Its ardor to express.

(Chorus)

שפֿילט אײַך, ליבע קינדערלעך,
Shpilt aykh, libe kinderlekh,

Play on, dearest little ones,

פֿאַרזוימט קיין אויגנבליק,
Farzoymt keyn oygnblik,

Do not waste the day

ווײַל דער פֿרילינג עקט זיך באַלד,
Vayl der friling ekt zikh bald

Because the spring will soon be gone

מיט אים דאָס העכסטע גליק.
Mit im dos hekhste glik.

And this joy will go away.

(Chorus)

(music on page 116)

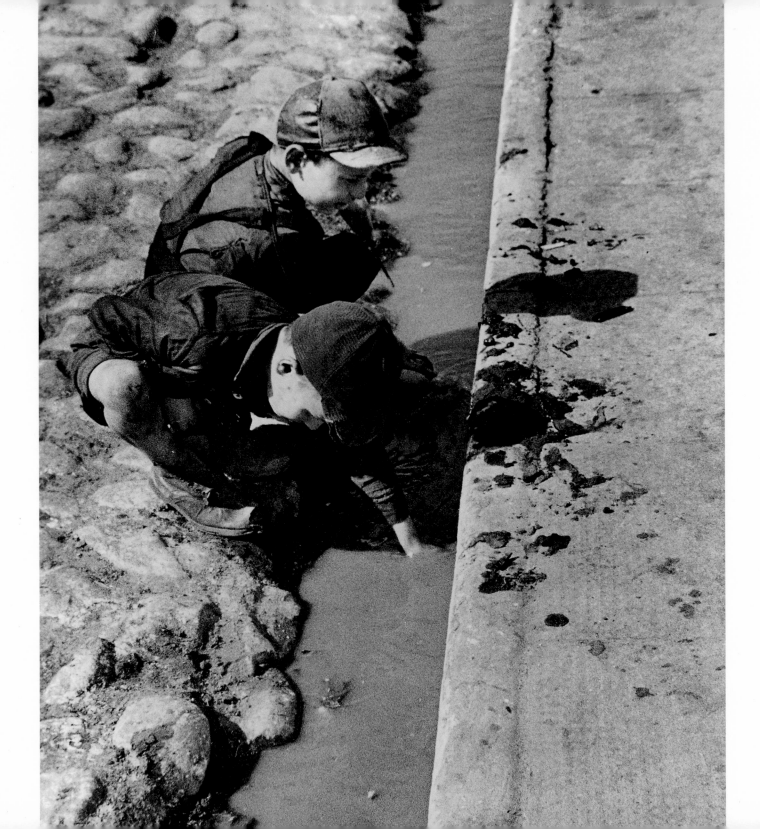

Dray Yingelekh

Three Little Boys

די מאַמע האָט דרײַ ייִנגעלעך
Di mame hot dray yingelekh

A mother had three little boys,

דרײַ ייִנגעלעך געהאַט.
Dray yingelekh gehat

Three little boys had she,

מיט ווייכע, רויטע בעקעלעך,
Mit veykhe, royte bekelekh

With cheeks as soft as smoothest silk

ווי צאַרטער סאַמעט גלאַט.
Vi tsarter samet glat.

And rosy as could be.

האָט איינס געהייסן בערעלע,
Hot eyns geheysn Berele,

The first one was called "Berele,"

דאָס צווייטע — חיים שמערעלע,
Dos tsveyte, Khayim-Shmerele,

The second "Khayim-Shmerele,"

דאָס דריטע האָט געהייסן
Dos drite hot geheysn

The third one was called, was called,

מען זאָל אים קויפֿן שיך.
Men zol im koyfn shikh.

Was called too late for lunch!

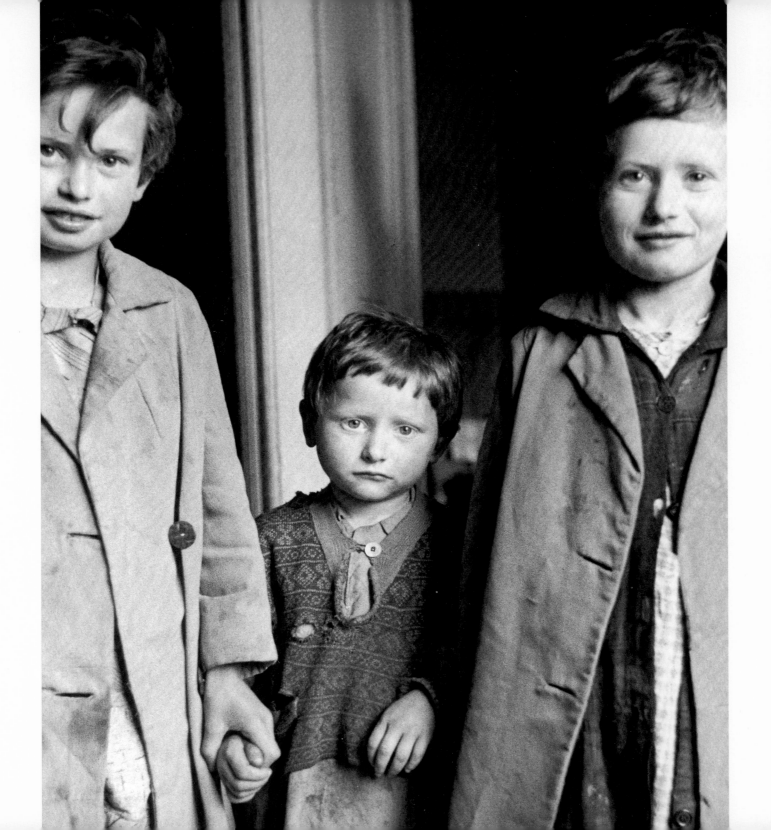

איך האָב אײַך אָפּגענאַרט,
Ikh hob aykh opgenart,

I fooled you all, I did,

איך האָב געוואוסט איר וואַרט.
Ikh hob gevust ir vart:

I am a fooling kid:

דאָס דריטע, קליינע ייִנגעלע —
Dos drite kleyne yingele,

The third one of the little boys,

דאָס דריטע דאָס בין איך.
Dos drite dos bin ikh.

The third one—that is me!

די מאַמע האָט דרײַ ניסעלעך
Di mame hot dray niselekh

A mother had three little nuts

פֿון דעם יאַריד געבראַכט,
Fun dem yarid gebrakht;

That she brought from the store;

דרײַ גוטע, פֿעטע ניסעלעך,
Dray gute, fete niselekh,

Three plump and shiny little nuts

דרײַ ניסעלעך אַ פּראַכט.
Dray niselekh a prakht.

With nuttiness galore!

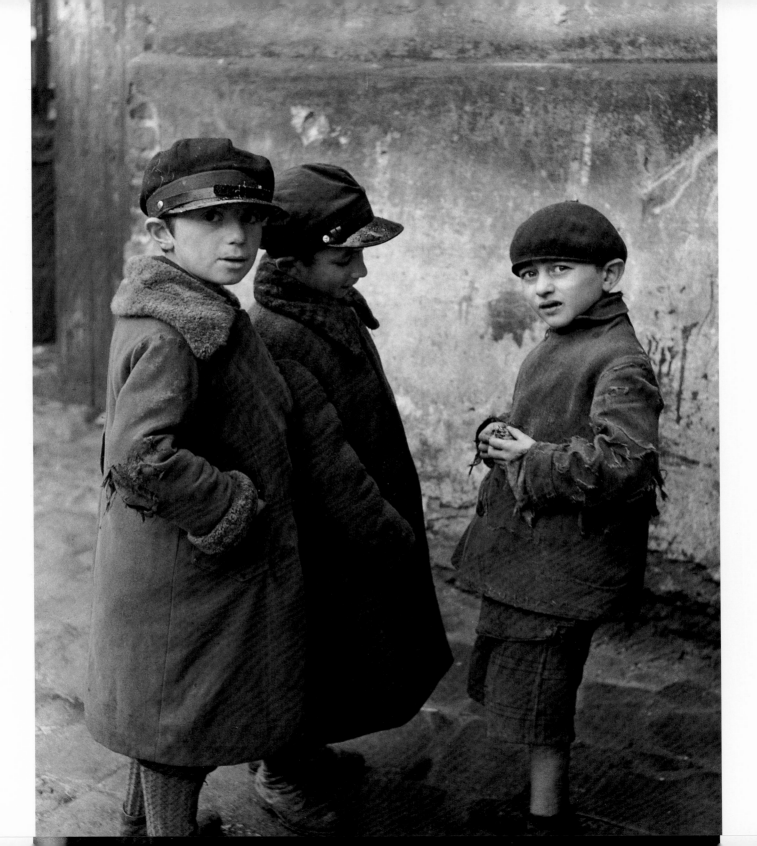

Rozhinkes mit Mandlen

Raisins and Almonds

אין דעם בית המקדש,
In dem beys hamikdesh

In the ancient Temple,

אין אַ ווינקל חדר,
in a vinkl kheyder

in an empty room,

זיצט די אלמנה בת־ציון אַליין.
Zitst di almone Bas-Tsiyen aleyn

The widow, Bas Zion, is sitting alone.

איר בן־יחידל, ייִדעלע,
Ir ben-yokhidl Yidele

She rocks her son Yidele

וויגט זי כסדר
vigt zi keseyder

and softly croons

און זינגט אים אַ לידעלע
Un zingt im a lidele

A lullaby song,

צום שלאָפֿן גיין.
tsum shlofn geyn.

a song of her own.

אַיַ, ליו, ליו, ליו
Ay-lyu-lyu-lyu.

Ay-lyu-lyu-lyu.

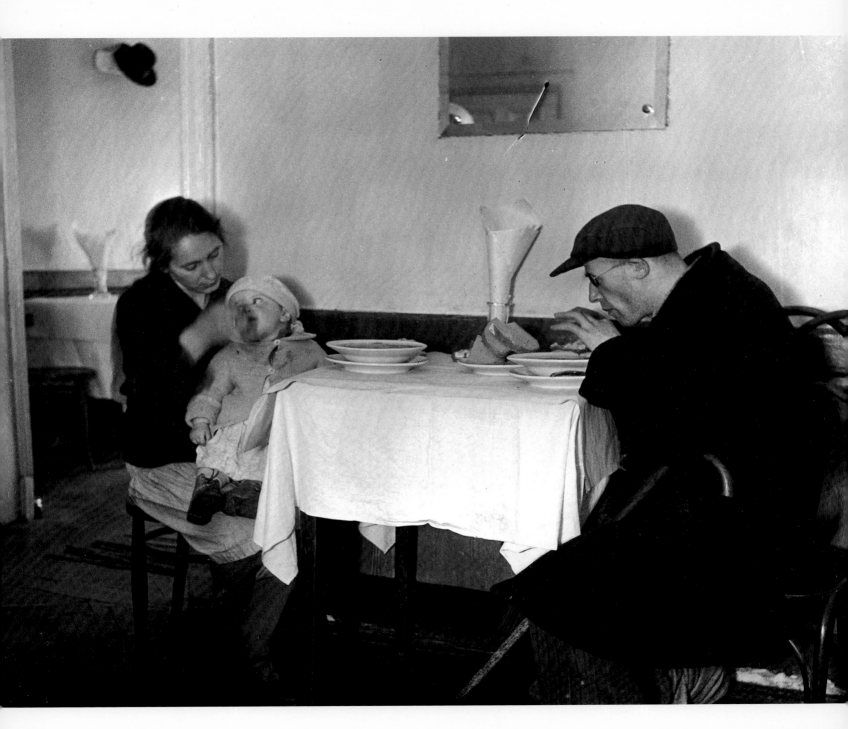

אונטער ייִדעלעס וויגעלע	Under Yidele's cradle there stands
Unter Yideles vigele	
שטייט אַ קלאָר ווײַס ציגעלע,	A little white goat from dreamlands;
Shteyt a klor vays tsigele	
דאָס ציגעלע איז געפֿאָרן האַנדלען.	The little goat traded and wandered
Dos tsigele iz geforn handlen	
דאָס וועט זײַן דײַן באַרוף,	And, my son, so will you.
Dos vet zayn dayn baruf	
ראָזשינקעס מיט מאַנדלען,	Raisins and almonds
Rozhinkes mit mandlen	
שלאָף־זשע, ייִדעלע שלאָף.	Sleep, my son, ay-lyu-lyu.
Shlof zhe, Yidele, shlof.	

(music on page 120)

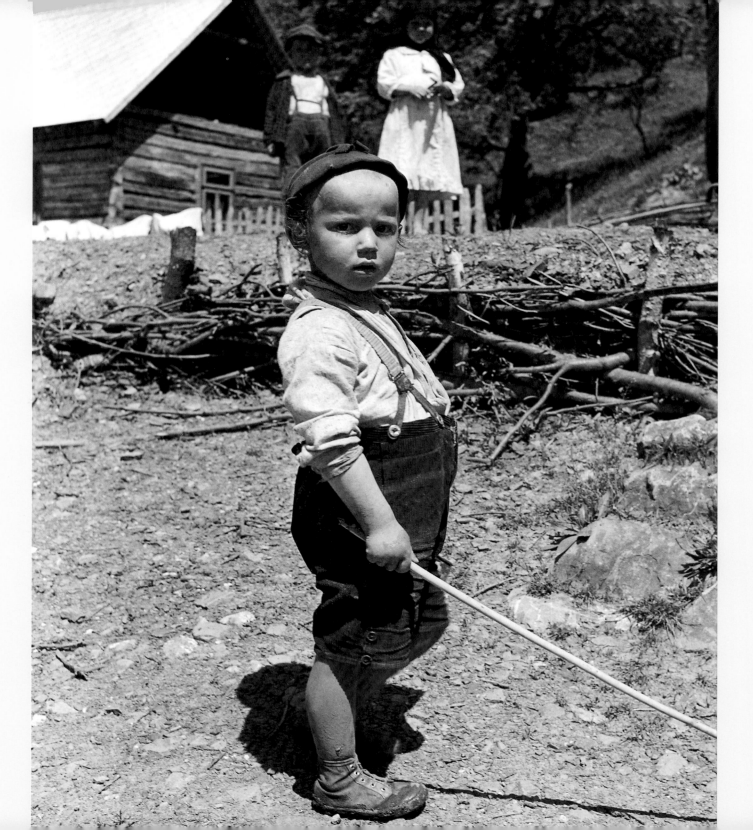

Help Ikh Mamen

Helping Mother

אַלע מאָנטיק וואשט מײַן מאַמע,
Ale montik vasht mayn mame,

Every Monday Mother washes,

העלף איך מאַמען וואַשן.
Helf ikh mamen vashn.

I help her with the washing.

העלף איך מאַמען וואַשן.
Helf ikh mamen vashn.

I help her with the washing.

אָט אַזוי און אָט אַזוי,
Ot azoy un ot azoy

This-a-way and that-a-way

העלף איך מאַמען וואַשן.
Helf ikh mamen vashn.

I help her with the washing.

אָט אַזוי און אָט אַזוי,
Ot azoy un ot azoy

This-a-way and that-a-way

העלף איך מאַמען וואַשן.
Helf ikh mamen vashn.

I help her with the washing.

אַלע דינסטיק פרעסט מײַן מאַמע,
Ale dinstik prest mayn mame,

Every Tuesday Mother irons,

העלף איך מאַמען פרעסן.
Helf ikh mamen presn.

I help her with the ironing.

אָט אַזוי און אָט אַזוי,
Ot azoy un ot azoy

This-a-way and that-a-way

העלף איך מאַמען פרעסן.
Helf ikh mamen presn.

I help her with the ironing.

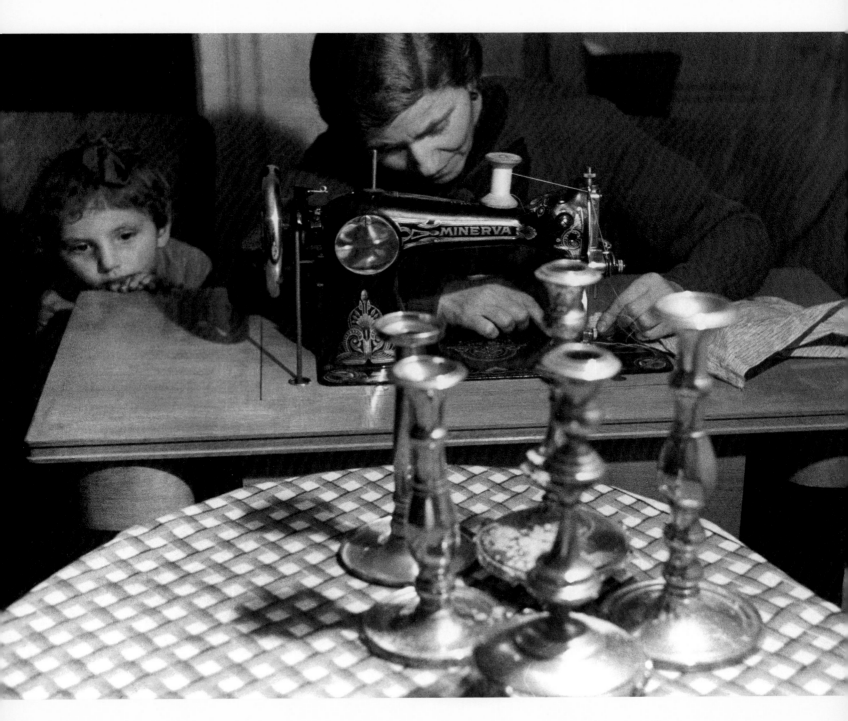

אַלע מיטוואָך קאָכט מײַן מאַמע,

Ale mitvokh kokht mayn mame,

Every Wednesday Mother cooks,

העלף איך מאַמען קאָכן.

Helf ikh mamen kokhn.

I help her with the cooking.

אָט אַזוי און אָט אַזוי,

Ot azoy un ot azoy

This-a-way and that-a-way

העלף איך מאַמען קאָכן.

Helf ikh mamen kokhn.

I help her with the cooking.

אַלע דאָנערשטיק קויפֿט מײַן מאַמע,

Ale donershtik koyft mayn mame,

Every Thursday Mother shops,

העלף איך מאַמען קויפֿן.

Helf ikh mamen koyfn.

I help her with the shopping.

אָט אַזוי און אָט אַזוי,

Ot azoy un ot azoy

This-a-way and that-a-way

העלף איך מאַמען קויפֿן.

Helf ikh mamen koyfn.

I help her with the shopping.

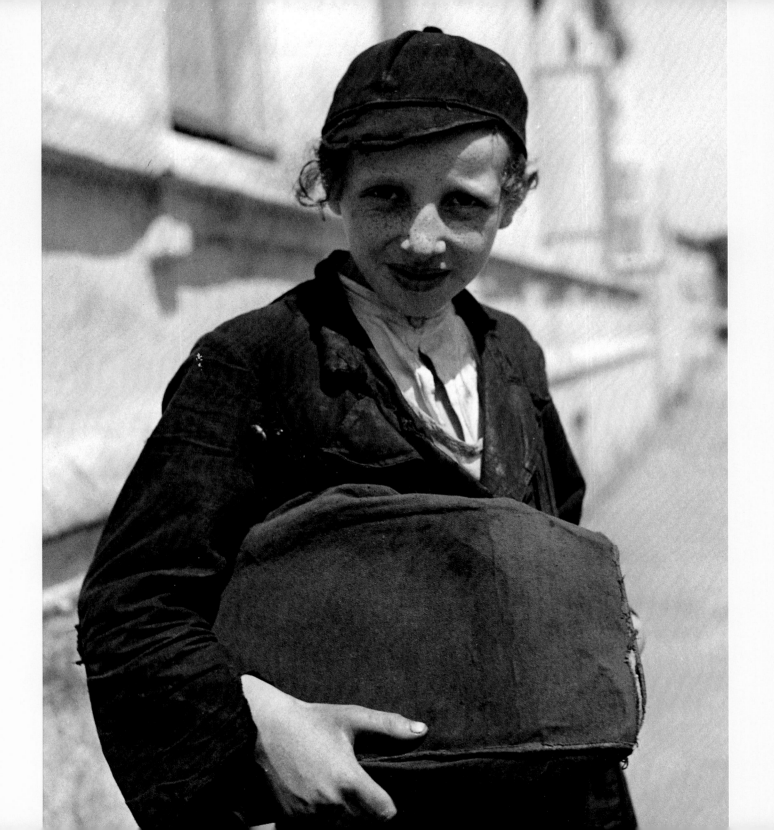

אַלע פֿרײַטיק ראַמט מײַן מאַמע,
Ale fraytik ramt mayn mame,

העלף איך מאַמען ראַמען.
Helf ikh mamen ramen.

אָט אַזוי און אָט אַזוי,
Ot azoy un ot azoy

העלף איך מאַמען ראַמען.
Helf ikh mamen ramen.

אַלע שבת רוט מײַן מאַמע,
Ale shabes rut mayn mame,

העלף איך מאַמען רוען.
Helf ikh mamen ruen.

אָט אַזוי און אָט אַזוי,
Ot azoy un ot azoy

העלף איך מאַמען רוען,
Helf ikh mamen ruen.

Every Friday Mother cleans,

I help her with the cleaning.

This-a-way and that-a-way

I help her with the cleaning.

Every Saturday Mother rests,

I help her with the resting.

This-a-way and that-a-way

I help her with the resting.

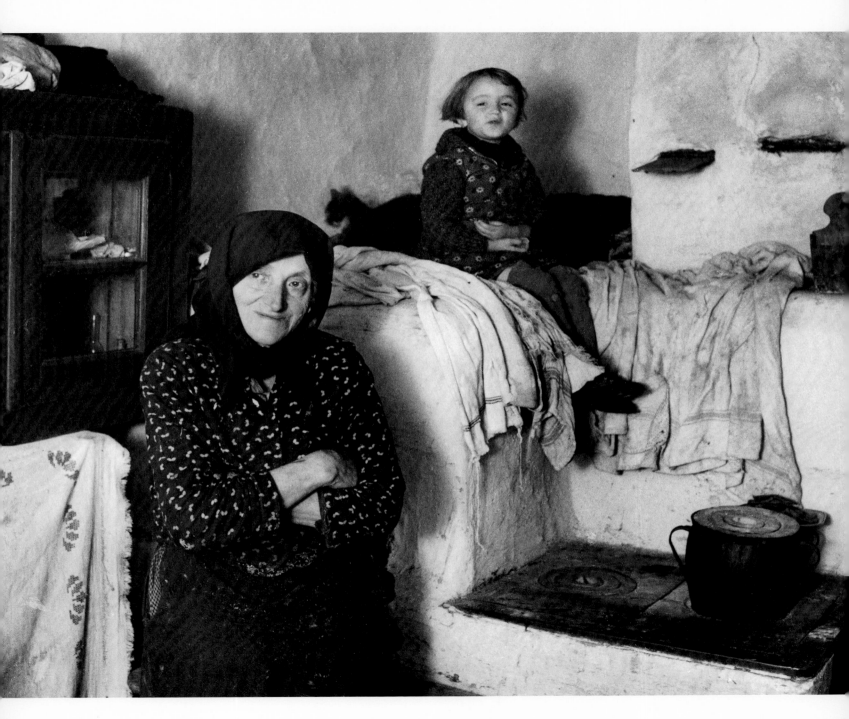

אַלע זונטיק מיט מײַן פּאַפּאַ,

Ale zuntik mit mayn papa,

Every Sunday with my Papa,

גייען מיר שפּאַצירן.

Geyen mir shpatsirn.

We all go out walking.

אָט אַזוי און אָט אַזוי,

Ot azoy un ot azoy

This-a-way and that-a-way

גייען מיר שפּאַצירן.

Geyen mir shpatsirn.

We all go out walking.

אָט אַזוי און אָט אַזוי,

Ot azoy un ot azoy

This-a-way and that-a-way

גייען מיר שפּאַצירן.

Geyen mir shpatsirn.

We all go out walking.

(music on page 122)

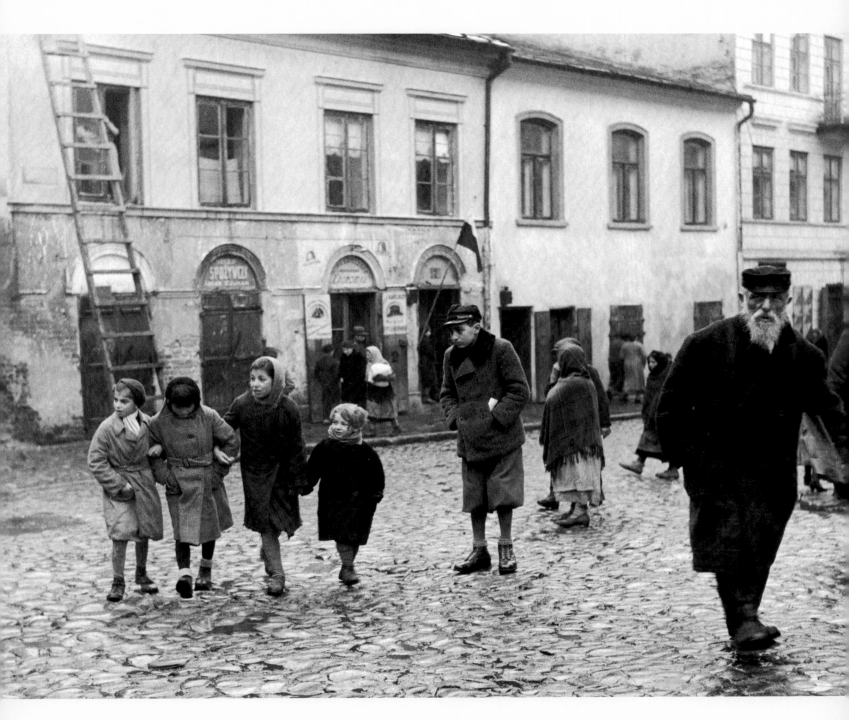

Tsu Dayn Geburtstog

Today Is Your Birthday

צו דײַן געבורטסטאָג,
Tsu dayn geburtstog

Today is your birthday

צו דײַן יום־טוב הײַנט,
Tsu dayn yontev haynt

And we all have come

האָבן זיך פֿאַרזאַמלט
Hobn zikh farzamlt

All your friends and family

דײַנע גוטע פֿרײַנט.
Dayne gute fraynt.

All your dear old chums.

הוראַ, הוראַ, מיר ווינטשן דיר,
Hura, hura, mir vintshn dir

Hooray, hooray, we're wishing you

הוראַ, הוראַ, מיר ווינטשן דיר,
Hura, hura, mir vintshn dir

Hooray, hooray, we're wishing you

מיר ווינטשן דיר געזונט און גליק.
Mir vintshn dir gezunt un glik.

We're wishing you a joyful life!

(music on page 124)

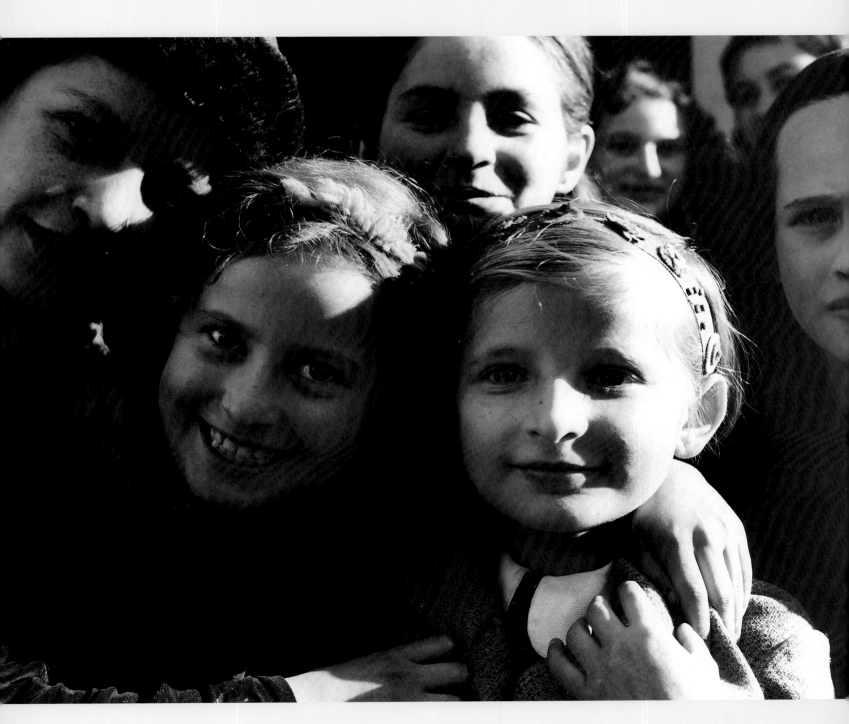

Tsipele

Tsipele

עס האָט די קליינע ציפעלע
Es hot di kleyne Tsipele

The little girl named Tsipele

פֿאַרביסן מיט אַ ליפּעלע.
Farbisn mit a lipele.

Was pouting, crying, too;

אוי, ציפּעלע, וואָס וויינסטו?
Oy, Tsipele, vos veynstu?

Oh, Tsipele, what is it?

אַן עפּעלע, דאָס מיינסטו?
An epele, dos meynstu?

An apple shall I give you?

אוי, ניין, ניין, ניין, ניין
Oy, neyn, neyn, neyn, neyn

Oh, no, no, no, no

ווער זאָגט עס, אַז איך וויין?
Ver zogt es az ikh veyn?

Who says I'm full of woe?

עס האָט די קליינע ציפּעלע,
Es hot di kleyne Tsipele

The little girl named Tsipele

פֿאַרקניפּט דאָס מויל אַ קניפּעלע.
Farknipt dos moyl a knipele.

Said sadly, "Oh, boo-hoo"

אוי, ציפּעלע, וואָס וויינסטו?
Oy, Tsipele, vos veynstu?

Oh, Tsipele, what is it?

צוויי עפּעלעך, דאָס מיינסטו?
Tsvey epelekh, dos meynstu?

Two apples shall I give you?

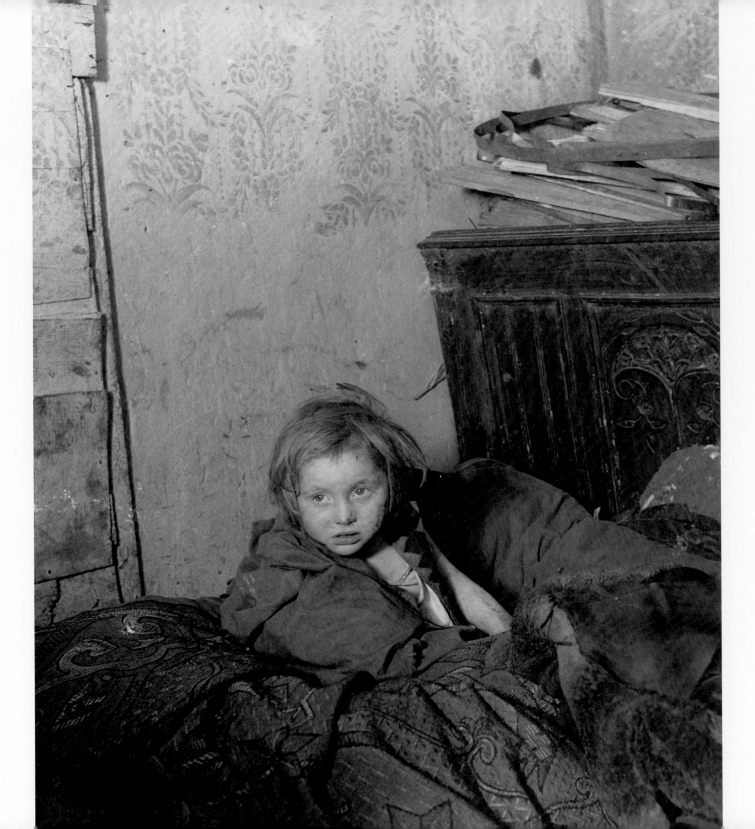

אוי, ניין, ניין, ניין, ניין

Oy, neyn, neyn, neyn, neyn

Oh, no, no, no, no

ווער זאָגט עס, אַז איך וויין?

Ver zogt es az ikh veyn?

Who says I'm full of woe?

און ס׳טרייסלט זיך איר קעפּעלע,

Un s'treyslt zikh ir kepele

And now she shakes her little head

צוזאַמען מיט איר צעפּעלע.

Tsuzamen mit ir tsepele.

Her braids go flying, all askew

אוי, ציפּעלע, וואָס וויינסטו?

Oy, Tsipele, vos veynstu?

Oh, Tsipele, what is it?

דרײַ עפּעלעך, דאָס מיינסטו?

Dray epelekh, dos meynstu?

Three apples shall I give you?

אוי, ניין, ניין, ניין, ניין,

Oy, neyn, neyn, neyn, neyn

Oh, no, no, no, no

איך וויל אַ קוש, ניט מיין.

Ikh vil a kush, nit meyn.

I want a kiss, no more!

(music on page 126)

CHILDREN OF A VANISHED WORLD

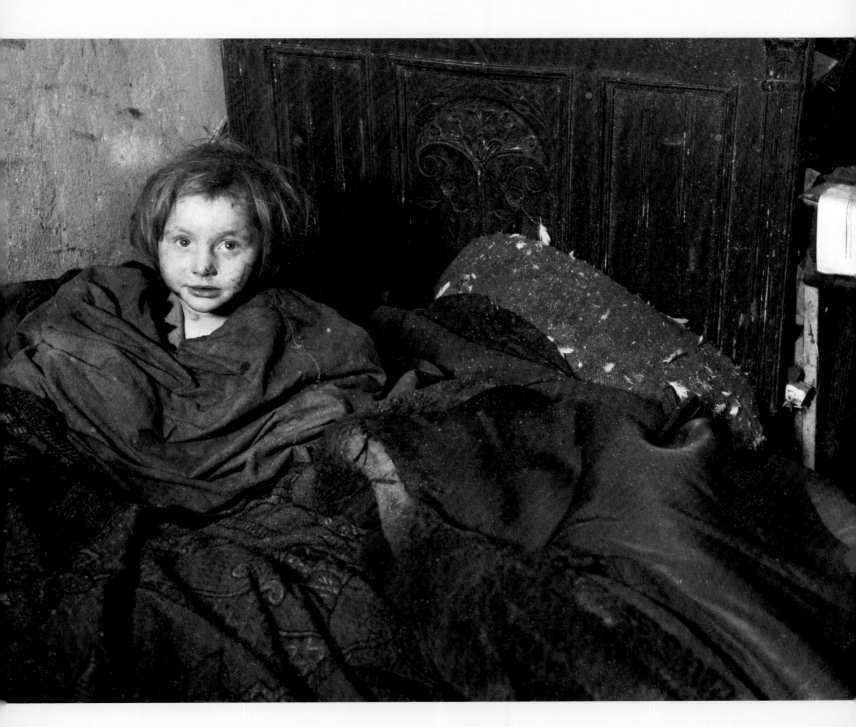

Hob Ikh Mir a Mantl

I Have Me a Little Coat

האָב איך מיר אַ מאַנטל פֿון פֿאַרצײַטיקן שטאָף,
Hob ikh mir a mantl fun fartsaytikn shtof

I have me a little coat of ancient design

טראַ־לאַ־לאַ־לאַ־לאַ־לאַ־לאַ־לאַ, לאַ־לאַ־לאַ
Tra-la-la-la-la-la-la-la, la-la-la

Tra-la-la-la-la-la-la-la, la-la-la

האָט עס ניט אין זיך קיין איינציקן שטאָך.
Hot es nit in zikh keyn eyntsikn shtokh

And not a stitch of it can stand the test of time

טראַ־לאַ־לאַ־לאַ־לאַ־לאַ־לאַ־לאַ, לאַ־לאַ־לאַ
Tra-la-la-la-la-la-la-la, la-la-la

Tra-la-la-la-la-la-la-la, la-la-la.

דאַרום, האָב איך זיך באַטראַכט
Darum, hob ikh zikh batrakht

One day an idea came to me:

פֿון דעם מאַנטל אַ רעקל געמאַכט!
Fun dem mantl a rekl gemakht!

From that little coat a jacket we shall see!

טראַ־לאַ־לאַ־לאַ־לאַ־לאַ־לאַ,
Tra-la-la-la-la-la-la

Tra-la-la-la-la-la-la,

טראַ־לאַ־לאַ־לאַ־לאַ־לאַ־לאַ
Tra-la-la-la-la-la-la

Tra-la-la-la-la-la-la

פֿון דעם מאַנטל אַ רעקל געמאַכט.
Fun dem mantl a rekl gemakht.

From that little coat a jacket we shall see.

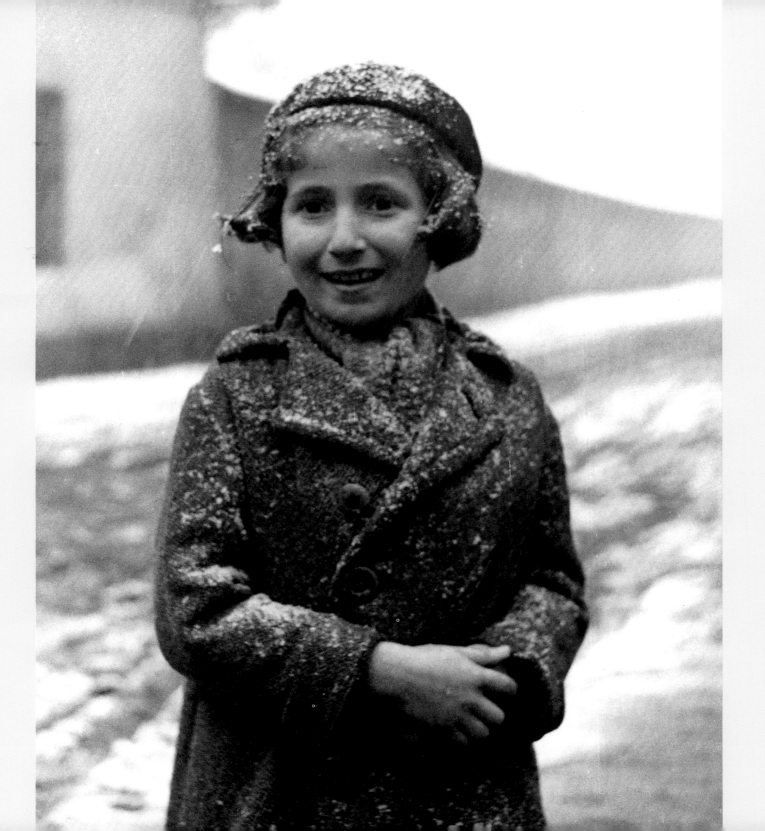

האָב איך מיר אַ רעקל פֿון פֿאַרצײַטיקן שטאָף,
Hob ikh mir a rekl fun fartsaytikn shtof

I have me a jacket of ancient design

האָט עס ניט אין זיך קיין איינציקן שטאָך.
Hot es nit in zikh keyn eyntsikn shtokh

And not a stitch of it can stand the test of time.

דאַרום, האָב איך זיך באַטראַכט
Darum, hob ikh zikh batrakht

One day an idea came to me:

פֿון דעם רעקל אַ וועסטל געמאַכט!
Fun dem rekl a vestl gemakht!

From that jacket, a waistcoat we shall see!

האָב איך מיר אַ וועסטל פֿון פֿאַרצײַטיקן שטאָף,
Hob ikh mir a vestl fun fartsaytikn shtof

I have me a waistcoat of ancient design

האָט עס ניט אין זיך קיין איינציקן שטאָך.
Hot es nit in zikh keyn eyntsikn shtokh

And not a stitch of it can stand the test of time

דאַרום, האָב איך זיך באַטראַכט
Darum, hob ikh zikh batrakht

One day an idea came to me:

פֿון דעם וועסטל אַ היטל געמאַכט!
Fun dem vestl a hitl gemakht!

From that waistcoat a little hat we'll see!

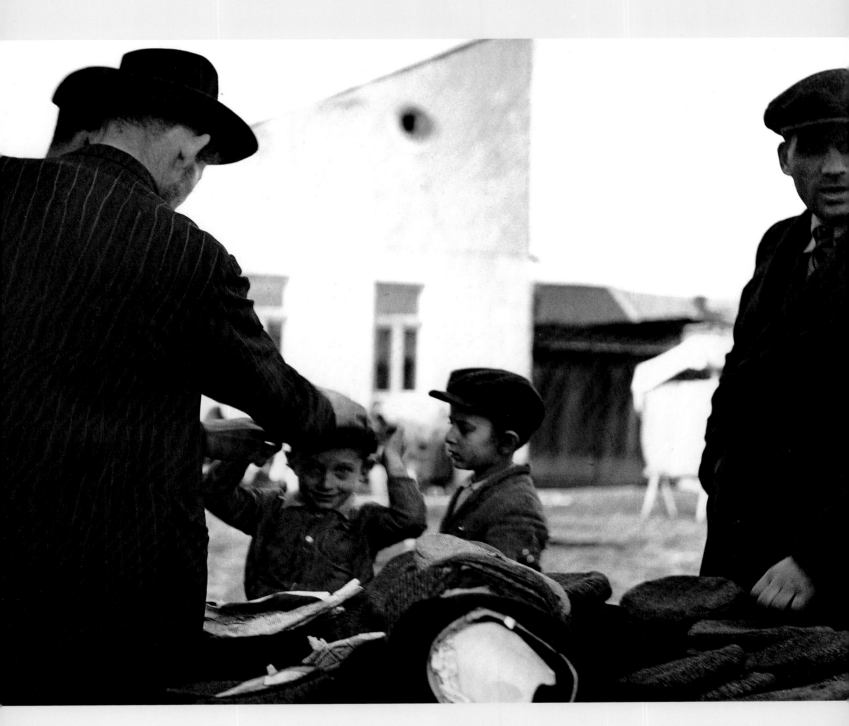

הָאָב איך מיר אַ היטל פֿון פֿאַרצײַטיקן שטאָף,

Hob ikh mir a hitl fun fartsaytikn shtof

I have me a hat of ancient design

הָאָט עס ניט אין זיך קיין איינציקן שטאָך.

Hot es nit in zikh keyn eyntsikn shtokh

And not a stitch of it can stand the test of time

דאַרום, הָאָב איך זיך באַטראַכט

Darum, hob ikh zikh batrakht

One day an idea came to me:

פֿון דעם היטל אַ קנעפּל געמאַכט!

Fun dem hitl a knepl gemakht!

From that little hat a button we shall see!

הָאָב איך מיר אַ קנעפּל פֿון פֿאַרצײַטיקן שטאָף,

Hob ikh mir a knepl fun fartsaytikn shtof

I have me a button of ancient design

הָאָט עס ניט אין זיך קיין איינציקן שטאָך.

Hot es nit in zikh keyn eyntsikn shtokh

And not a stitch of it can stand the test of time

דאַרום, הָאָב איך זיך באַטראַכט

Darum, hob ikh zikh batrakht

One day an idea came to me:

פֿון דעם קנעפּל אַ גאָרנישטל געמאַכט!

Fun dem knepl a gornishtl gemakht!

From that button a nothing we shall see!

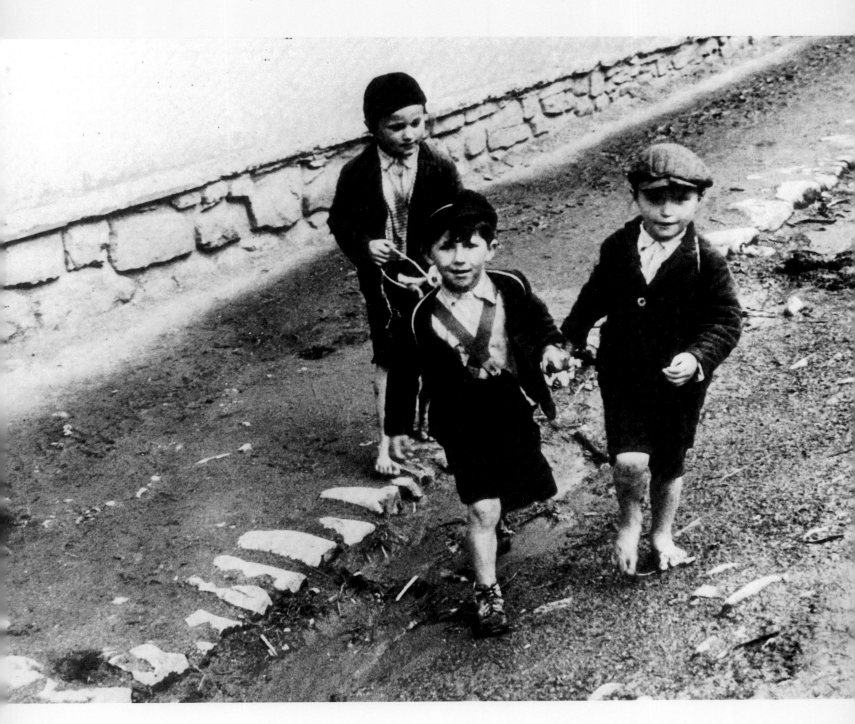

הָאָב איך מיר אַ גאָרנישטל פֿון פֿאַרצײַטיקן שטאָף,

Hob ikh mir a gornishtl fun fartsaytikn shtof

הָאָט עס ניט אין זיך קיין איינציקן שטאָך.

Hot es nit in zikh keyn eyntsikn shtokh

דאַרום, הָאָב איך זיך באַטראַכט

Darum, hob ikh zikh batrakht

פֿון דעם גאָרנישטל אַ לידעלע געמאַכט!

Fun dem gornishtl a lidele gemakht!

I have me a nothing of ancient design

And not a stitch of it can stand the test of time.

One day an idea came to me:

From that nothing this little song we see!

(music on page 128)

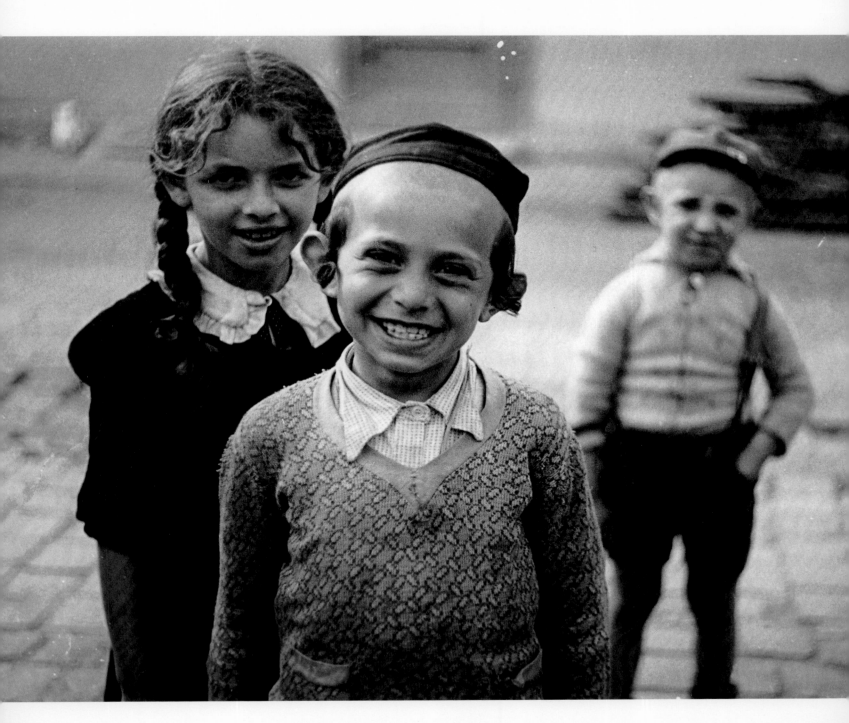

Mame un Kind

Mother and Child

יעדע מאַמע לויבט איר קינד,
Yede mame loybt ir kind,

All mothers rave about their kids,

אַז עס איז דאָס בעסטע;
Az es iz dos beste;

Each thinks that hers is best;

איך האָב אַ קינד און לויב עס נישט,
Ikh hob a kind un loyb es nisht,

I have a kid and do not rave:

איך ווייס: עס איז דאָס בעסטע!
Ikh veys: es iz dos beste!

I know that mine is best.

יעדע מאַמע לויבט איר קינד,
Yede mame loybt ir kind,

All mothers rave about their kids,

אַז עס איז דאָס שענסטע;
Az es iz dos shenste;

Each thinks that hers is fairest;

איך האָב אַ קינד און לויב עס נישט,
Ikh hob a kind un loyb es nisht,

I have a kid and do not rave:

איך ווייס: עס איז דאָס שענסטע!
Ikh veys: es iz dos shenste!

I know that mine is fairest.

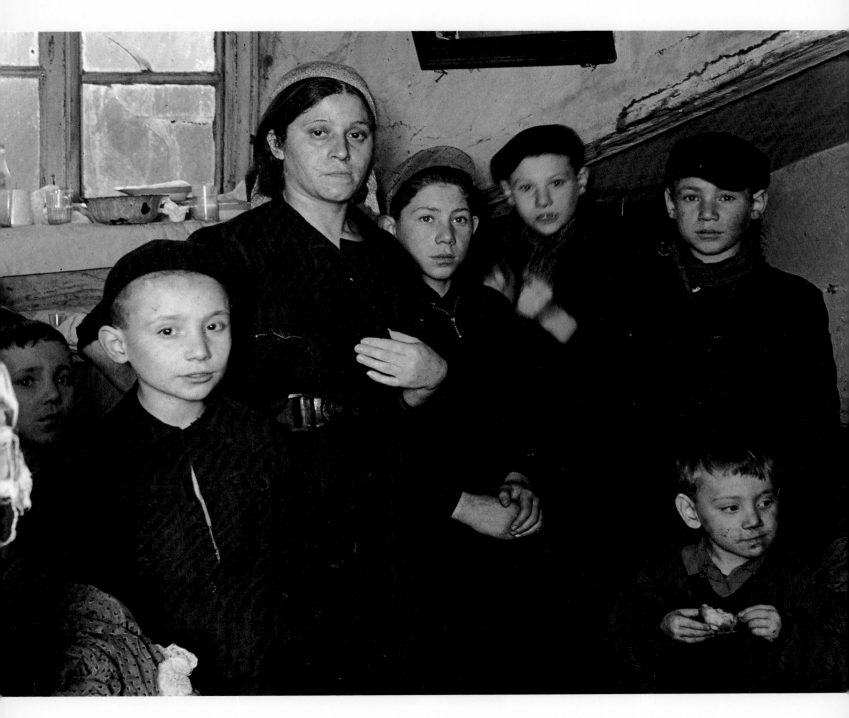

יעדע מאַמע לויבט איר קינד,
Yede mame loybt ir kind,

All mothers rave about their kids,

און אומזיסט דאָס לויבן;
Un umzist dos loybn;

And say they never grieve her;

מע שאָקלט מיטן קאָפּ נאָר צו —
Me shoklt mitn kop nor tsu—

People smile and nod their heads,

קיינער וועט נישט גלויבן!
Keyner vet nisht gloybn!

But they do not believe her.

איך האָב דאָס שענסטע, בעסטע קינד.
Ikh hob dos shenste, beste kind,

I have the finest, fairest child

און טו עס גאָרנישט לויבן;
Un tu es gornisht loybn;

And no one need believe me;

כאָטש ווער אויגן האָט, דער זעט
Khotsh ver oygn hot, der zet

It's clear to the entire world,

און באַדאַרף נישט גלויבן!
Un badarf nisht gloybn!

You've only just to look and see!

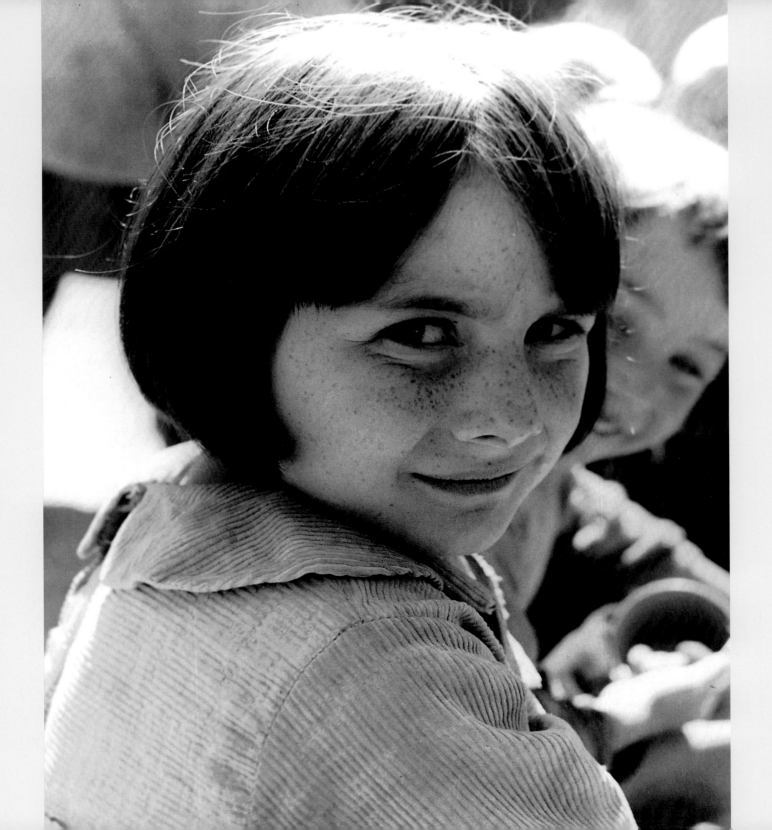

Nit Vashn!

No Washing!

קליין געצעלע פֿרייט זיך, װען ס׳באָדט אים די מאַמע,
Kleyn Getzele freyt zikh, ven s'bodt im di mame,

און צאַפּלט פֿאַר שׂימחה מיט הענט און מיט פֿיס.
Un tsaplt far simkhe mit hent un mit fis.

ער שפּרינגט און ער שװימט אין דער קלייניקער װאַנע,
Er shpringt un er shvimt in der kleyniker vane,

ער שפּרינגט װי אַ זאָרגלאָזער גליקלעכער פֿיש.
Er shpringt vi a zorglozer gliklekher fish.

עס װערט אָבער גלײַך אַ פֿאַרשטערטע זײַן שׂימחה,
Es vert ober glaykh a farshterte zayn simkhe,

װיבאַלד נאָר דעם שװאָם מיטן זייף ער דערזעט:
Vibald nor dem shvom mitn zeyf er derzet;

דאַן שרײַט ער מיט שרעק אויס: „אָ, גוטינקע מאַמע!"
Dan shrayt er mit shrek oys: "O gutinke mame!"

און פּאַטשט מיט די הענטלעך: „ניט װאַשן, איך בעט!"
Un patcht mit di hentelekh: "Nit vashn, ikh bet!"

No Washing!

Little Yosl is joyous when his mom gives him a bath;

To swim about it is his dearest wish.

He plays and leaps about in the little tub of water

And frolics like a carefree, happy fish.

His happiness is soon disturbed:

A soap bar ends his sloshing.

He screams with fright: "Oh, Mommy, dear,

I beg of you, no washing!"

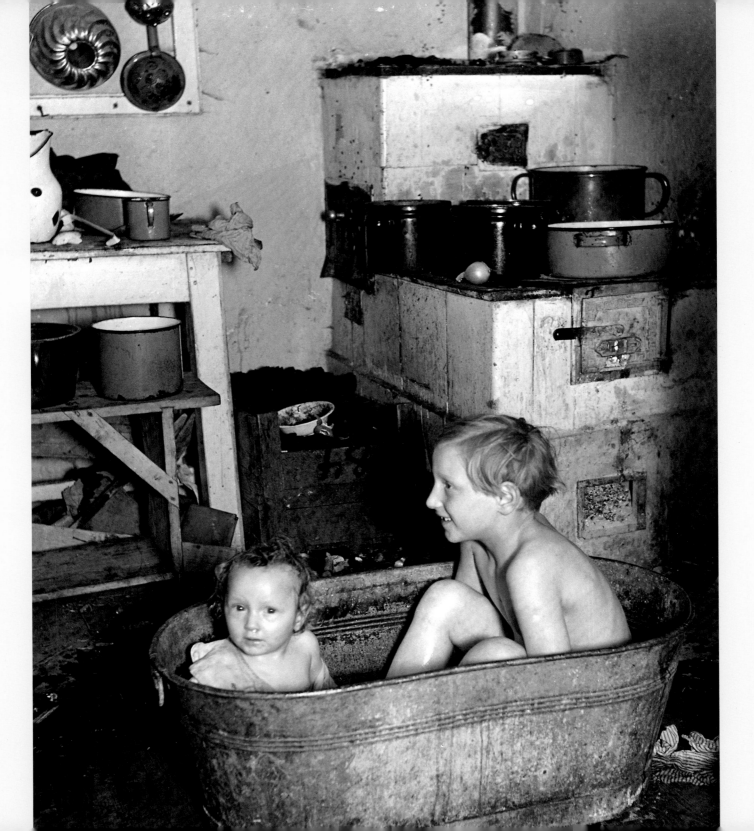

Eyns—A Nisl One—A Nut

איינס — אַ ניסל,
Eyns—a nisl

One—a nut

צוויי — אַ צווילינג,
Tsvey—a tsviling

Two—twins

דרײַ — מ׳זומן,
Dray—m'zumen

Three—coins

פֿיר — רעדער,
Fir—reder

Four—wheels

פֿינף — פֿינגער,
Finf—finger

Five—fingers

זעקס — קינדער,
Zeks—kinder

Six—children

זיבן — געקליבן,
Zibn—geklibn

Seven—gathered

אַכט — געטראַכט,
Akht—getrakht

Eight—think straight

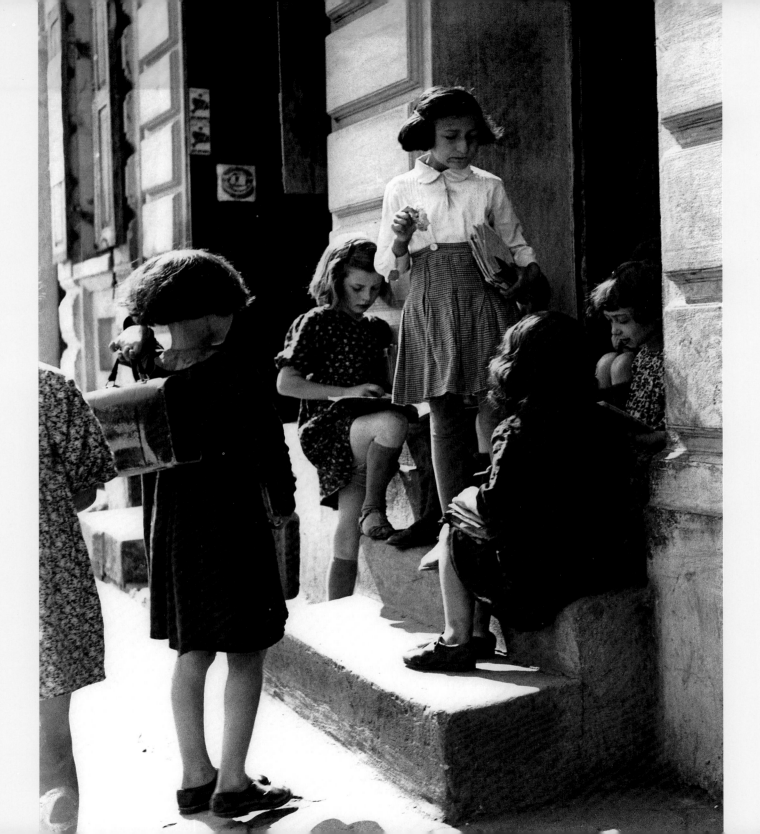

נײַן — גראַד,
Nayn—grad

Nine—degrees

צען — געזען,
Tsen—gezen

Ten—seeing men

עלף — אַ פּגר,
Elf—a peyger

Eleven—a carcass

צוועלף — אַ זייגער,
Tsvelf—a zeyger

Twelve—a clock

דרײַצן — בײַטשן,
Draytsn—baytshn

Thirteen—switches

פֿערצן — שערצן,
Fertsn—shertsn

Fourteen—stitches

פֿופֿצן גראָשן איז אַ האַלבער גילדן.
Fuftsn groshn iz a halber gildn.

Fifteen *groshn* make half a crown.

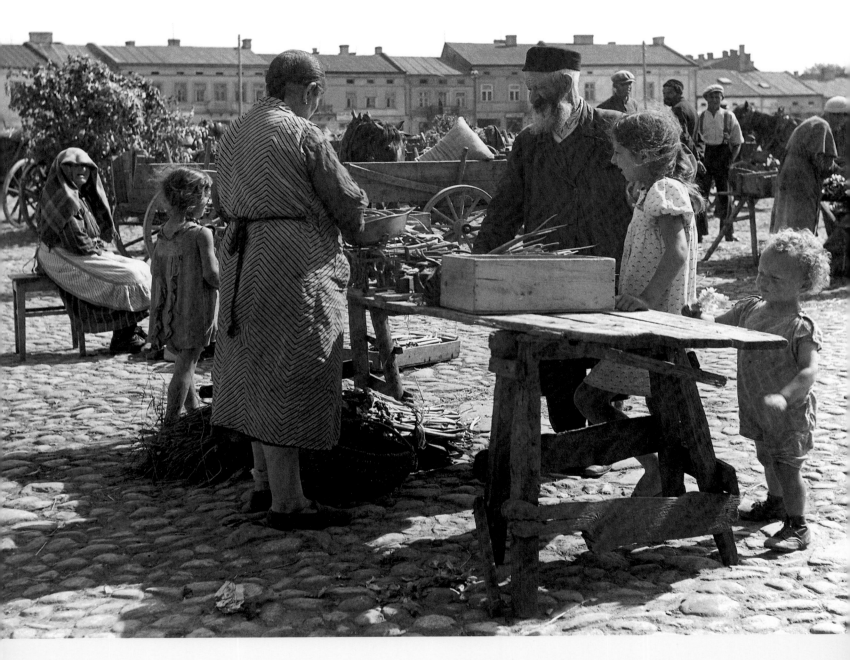

Di Toyb The Dove

די טויב איז געפֿלויגן
Di toyb iz gefloygn

The dove flew

איבער אַלע לענדער,
iber alle lender

Over all the world

האָט זי געזען אַ שיינע לאַנד,
Hot zi gezen a sheyne land

And saw a lovely land

איז די לאַנד צוגעשלאָסן,
Iz di land tsugeshlosn

But the land was locked

איז דער שליסל אָפֿגעבראָכן.
Iz der shlisl opgebrokhn

And the key was broken

אײנס, צוויי, דרײַ,
Eyns, tsvey, dray

One, two, three

גיי דו אַרויס פֿרײַ!
Gey du aroys fray.

Out you go.

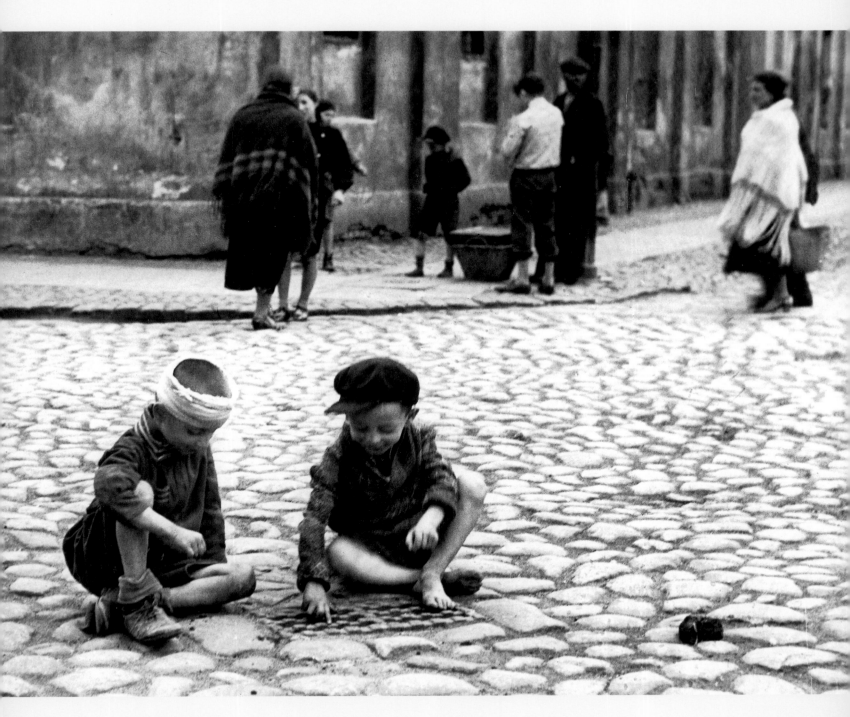

Eyn Mol Arum Once Around

אײן מאָל אַרום, צװײ מאָל אַרום,
Eyn mol arum, tsvey mol arum

Once around, twice around

שׂרהן האָט זיך פֿאַרדרײט די קעפּעלע.
Soren hot zikh fardreyt di kepele.

Sarah's head got dizzy.

אײן מאָל אַרום, צװײ מאָל אַרום,
Eyn mol arum, tsvey mol arum

Once around, twice around

שׂרה, שׂרה, דרײ זיך אום!
Sore, Sore, drey zikh um.

Sarah, Sarah, turn again.

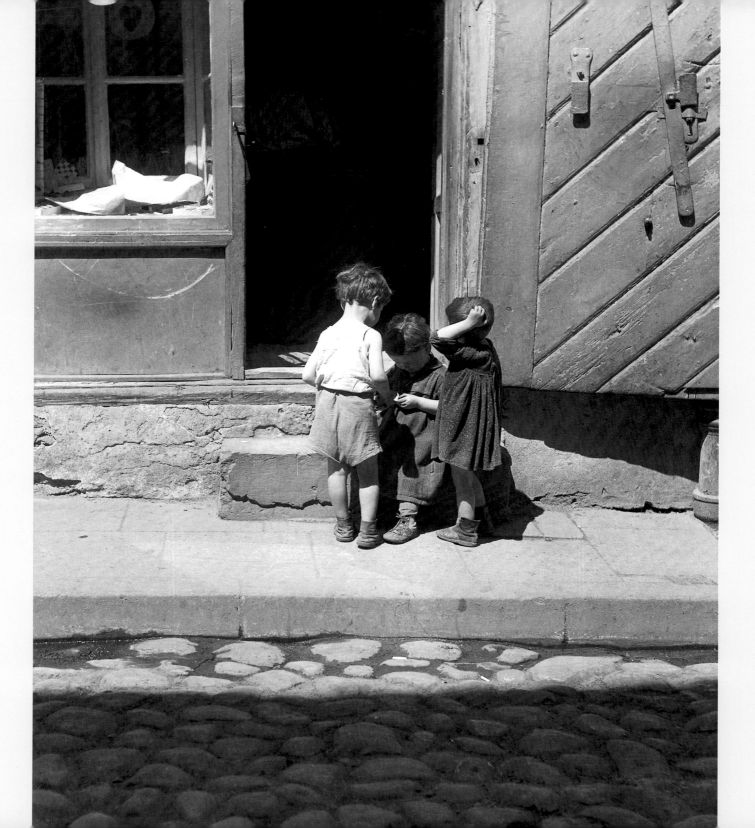

Undzer Got Zitst in Himl Our God Sits in Heaven

אונדזער גאָט זיצט אין הימל
Undzer got zitst in himl

Our God sits in heaven

און גיט צו עסן ברויט מיט קימל;
Un git tsu esn broyt mit kiml

And serves up bread with caraway seeds;

זייער גאָט שטייט אין פֿעלד
Zeyer got shteyt in feld

Their God stands in the field

און האָט אַ מכּה, נישט קיין געלט.
Un hot a make, nisht keyn gelt.

And has no money, just disease.

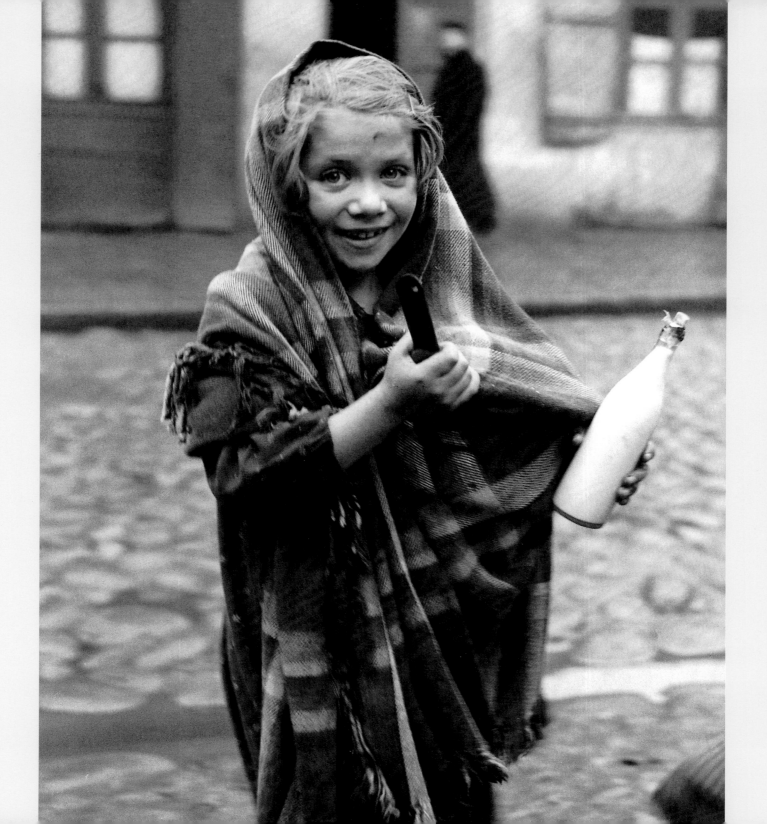

Der Rebe The Rebe

דער רבי גייט,
Der rebe geyt

The *rebe* paces,

דאָס בענקעלע שטייט;
Dos benkele shteyt

Chairs in their places,

דער רבי שמײַסט,
Der rebe shmayst

The *rebe* switches,

דער תּחת בײַסט.
Der tokhes bayst.

The *tokhes* itches.

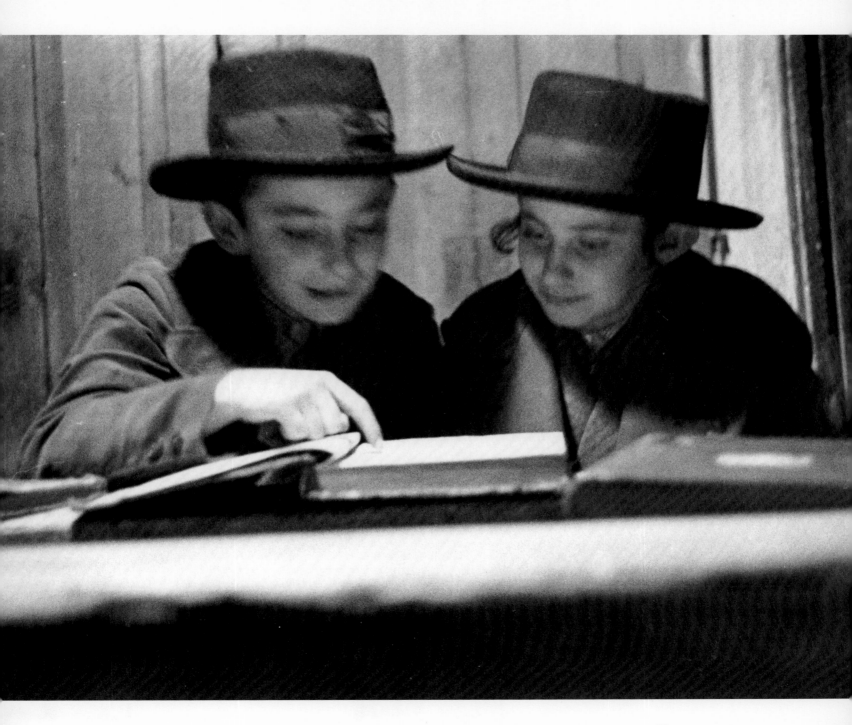

93

Beys, a Shtibele

Beys—A Little House

בית, אַ שטיבעלע — טאָ כאַטאַ,
Beys, a shtibele—to, khata

Beys—a little house—thus, *khata*

אם, אַ מוטער — טאָ מאַמאַ,
Eem, a muter—to, mama

Eym—a mother—thus, *mama*

אָב, אַ פֿאָטער — טאָ טאַטאַ.
Ov, a foter—to, tata

Ov—a father—thus, *tata*

דרך, אַ וועג — טאָ דראָגאַ,
Derekh, a veg—to, droga

Derekh—a road—thus, *droga*

יד, אַ האַנט — טאָ רוקאַ,
Yad, a hant—to, ruka

Yad—a hand—thus, *ruka*

רגל, אַ פֿוס — טאָ נאָגאַ.
Regel, a fus—to, noga

Regel—a foot—thus, *noga*

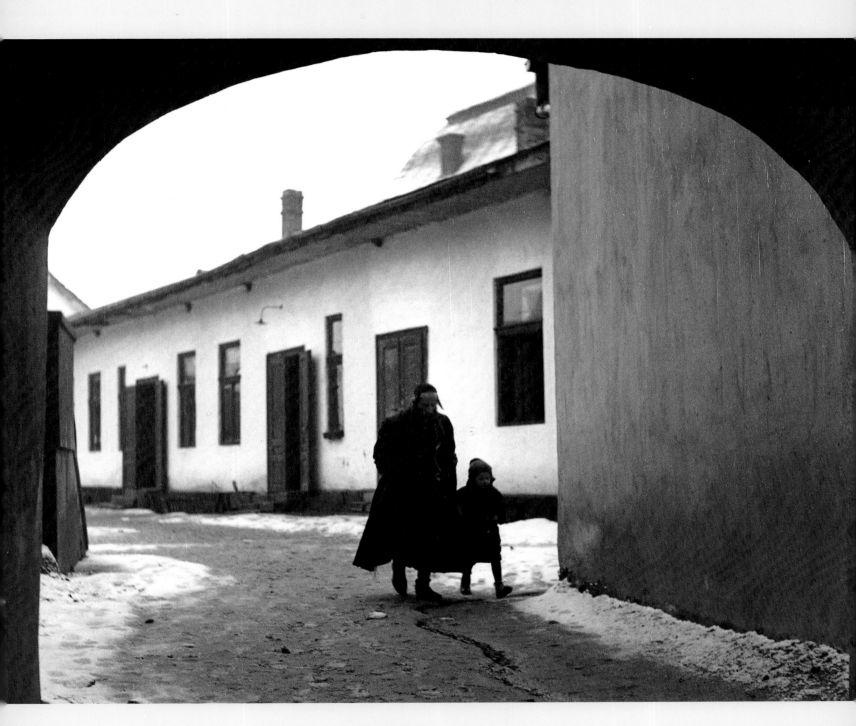

Lashinke, Vaysinke

לאַשינקע װײַסינקע, אַװוּ ביסטו געװען?
Lashinke, vaysinke, avu bistu geven?

Little boy, little boy, where did you go?

בײַם האַר געװען.
Baym har geven.

I went to the squire's house.

װאָס האָסטו פֿאַרדינקט? אַ שטיקעלע קעז.
Vos hostu fardint? A shtikele kez.

What did you earn? A piece of cheese.

אַװוּ האָסטו געלייגט? אין פּאָפּיעץ.
Avu hostu geleygt? In popyets.

Where did you put it? In the churchyard.

אַװוּ אין דער פּאָפּיעץ? מיט װאַסער פֿאַרלאָפֿן.
Avu iz der popyets? Mit vaser farlofn.

Where is the churchyard? Flooded by water.

אַװוּ אי׳ די װאַסער? אָקסן אויסגעטרונקען.
Avu i' di vaser? Oksn oysgetrunken.

Where is the water? Oxen drank it.

אַװוּ אי׳ די אָקסן? דובינעס האָבן צעהרגעט.
Avu i' di oksn? Dubinem hobn tseharget.

Where are the oxen? Oak trees fell on them.

אַװוּ די דובינעס? װערעם האָבן געגעסן.
Avu di dubinem? Verem hobn gegesn.

Where are the oak trees? Worms ate them.

אַװוּ זײַנען די װערעם? הינער האָבן צעפּיקט.
Avu zaynen di verem? Hiner hobn tsepikt.

Where are the worms? Chickens ate them.

אַװוּ זײַנען די הינער? אויפֿן פֿעלד אַװעקגעפֿלויגן.
Avu zaynen di hiner? Oyfn feld avekgefloygn.

Where are the chickens? Flew away to the fields.

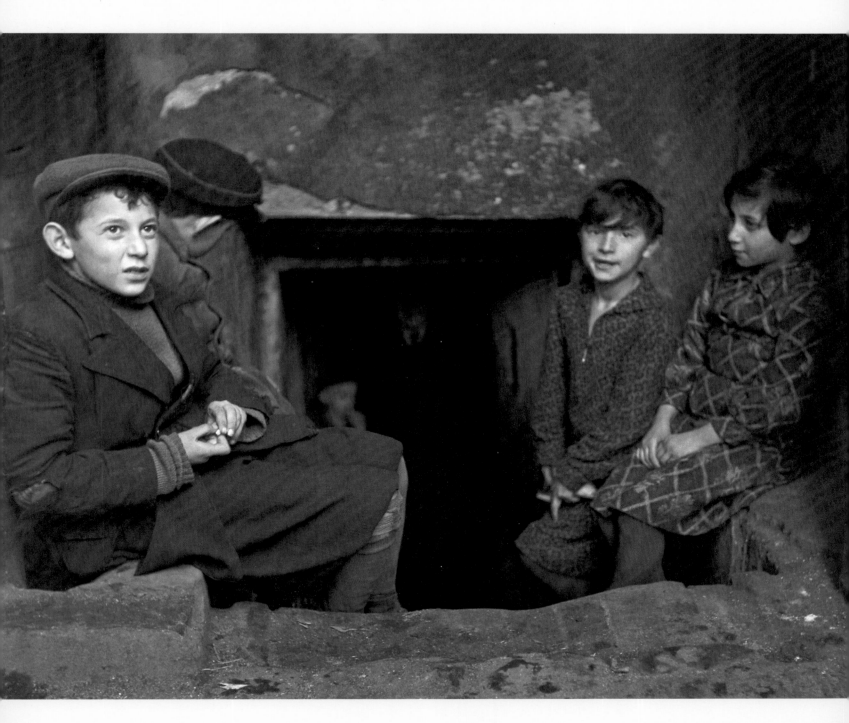

אַוואו אי׳ די פֿעלד? מיט קראַשקעס פֿאַרוואָקסן.
Avu i' di feld? Mit krashkes farvoksn.

Where are the fields? Overgrown with flowers.

אַוואו אי׳ די קראַשקעס? מיידלעך האָבן צעריסן.
Avu i' di krashkes? Meydlekh hobn tserisn.

Where are the flowers? Girls have picked them.

אַוואו זײַנען די מיידלעך? ייִנגלעך האָבן גענומען.
Avu zaynen di meydlekh? Yinglekh hobn genumen.

Where are the girls? Boys have taken them.

אַוואו זײַנען די ייִנגלעך? אויף מלחמה אַוועקגעלאָפֿן.
Avu zaynen di yinglekh? Oyf milkhome avekgelofn.

Where are the boys? Gone to war.

אַוואו אי׳ די מלחמה? ביז די קני אין בלוט.
Avu i' di milkhome? Biz di kni in blut.

Where is the war? Up to its knees in blood.

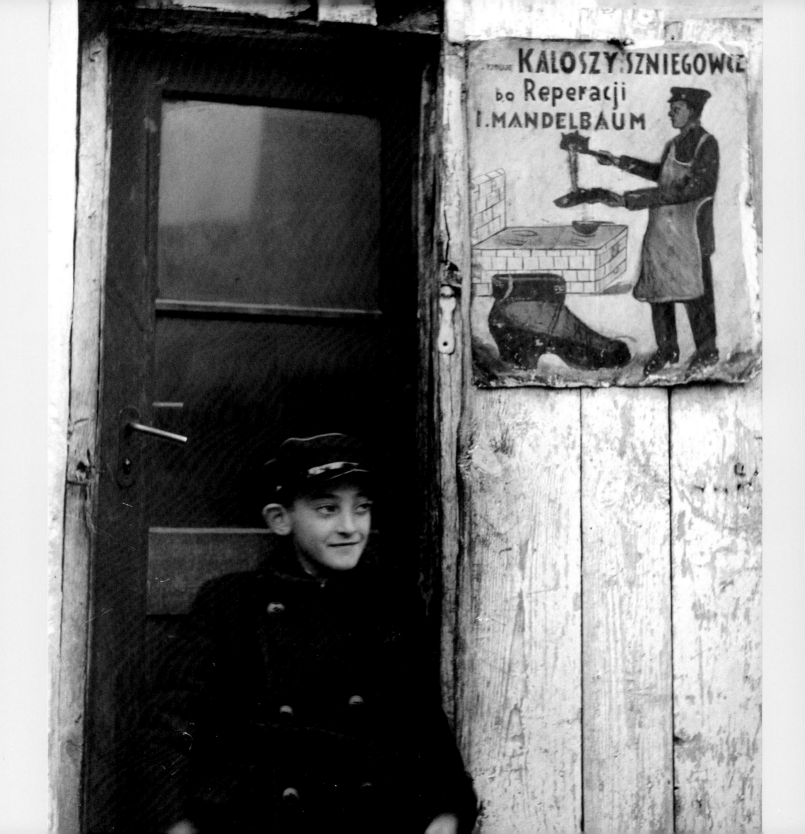

Oy, Vey Iz Mir Gesheyn What Happened to Me

אוי ווי איז מיר געשײן,
Oy, vey iz mir gesheyn,

מיט אַ מיידל איז גוט צו גיין;
Mit a meydl iz gut tsu geyn;

נישט ביַי טאָג, אוי, נאָר ביַי נאכט,
Nisht bay tog, oy, nor bay nakht,

ווען אַלע טויערן זענען צוגעמאַכט.
Ven ale toyern zenen tsugemakht.

What happened to me, oh woe,

With a girl it's good to go;

Not in daytime, only at night,

When all the doors are locked up tight.

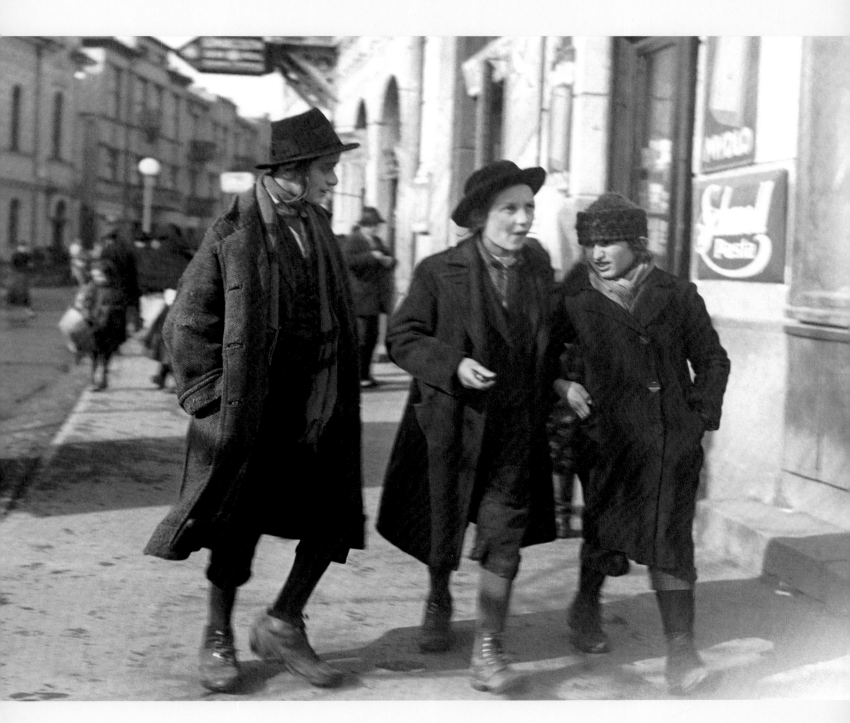

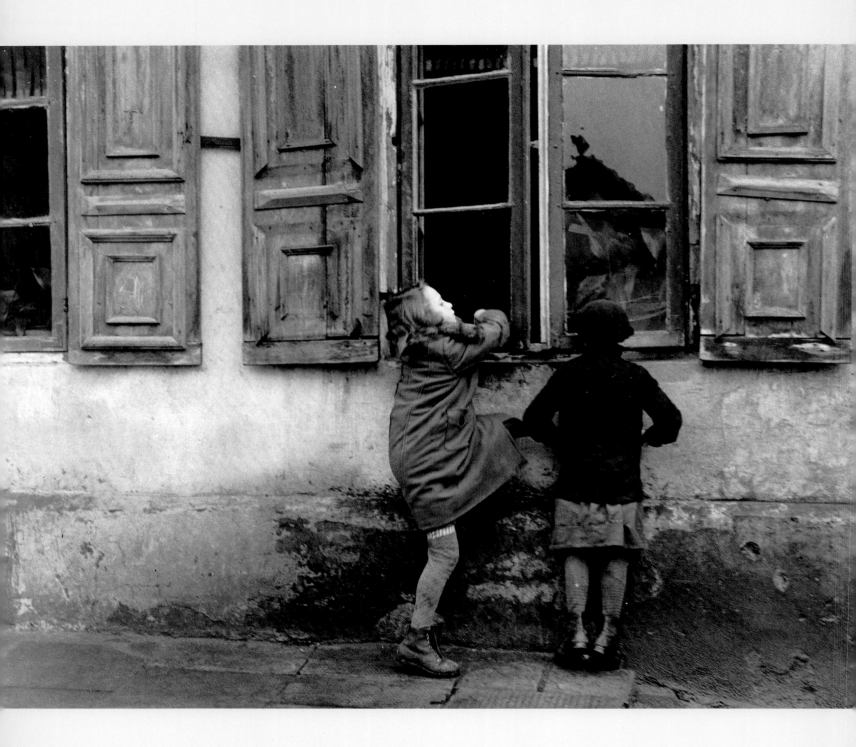

Music

Bulbes Potatoes

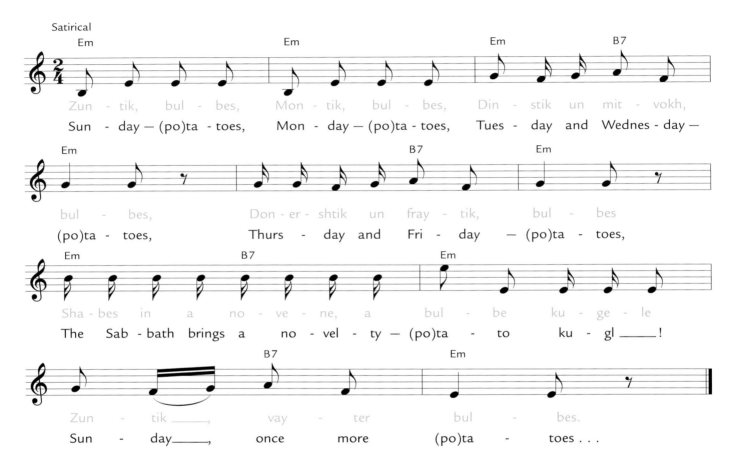

Satirical

Zun - tik, bul - bes, Mon - tik, bul - bes, Din - stik un mit - vokh,
Sun - day — (po)ta - toes, Mon - day — (po)ta - toes, Tues - day and Wednes - day —

bul - bes, Don - er - shtik un fray - tik, bul - bes
(po)ta - toes, Thurs - day and Fri - day — (po)ta - toes,

Sha - bes in a no - ve - ne, a bul - be ku - ge - le
The Sab - bath brings a no - vel - ty — (po)ta - to ku - gl ___!

Zun - tik ___, vay - ter bul - bes.
Sun - day ___, once more (po)ta - toes . . .

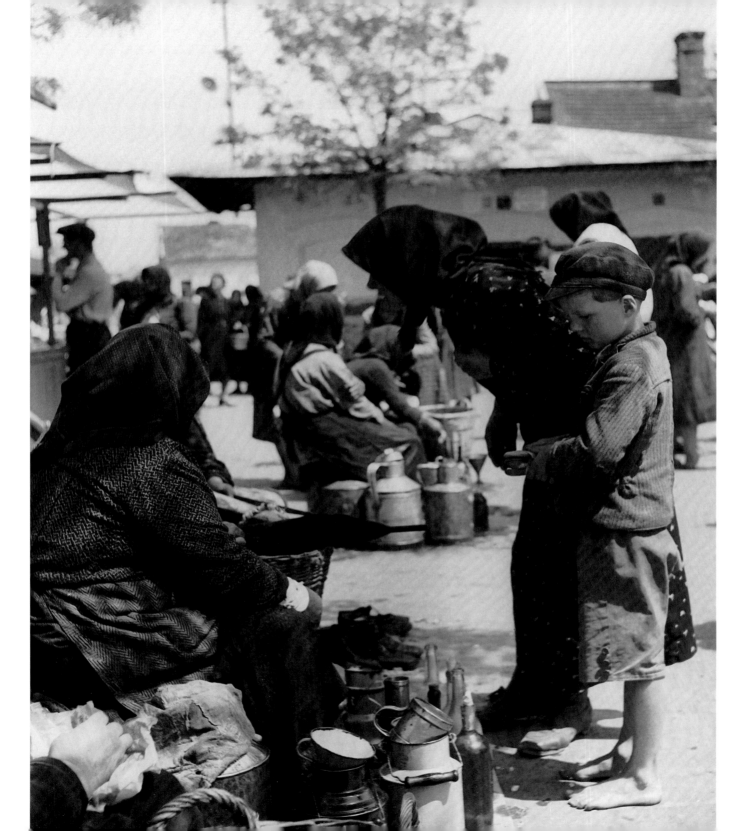

Bin Ikh Mir a Shnayderl I Am a Little Tailor

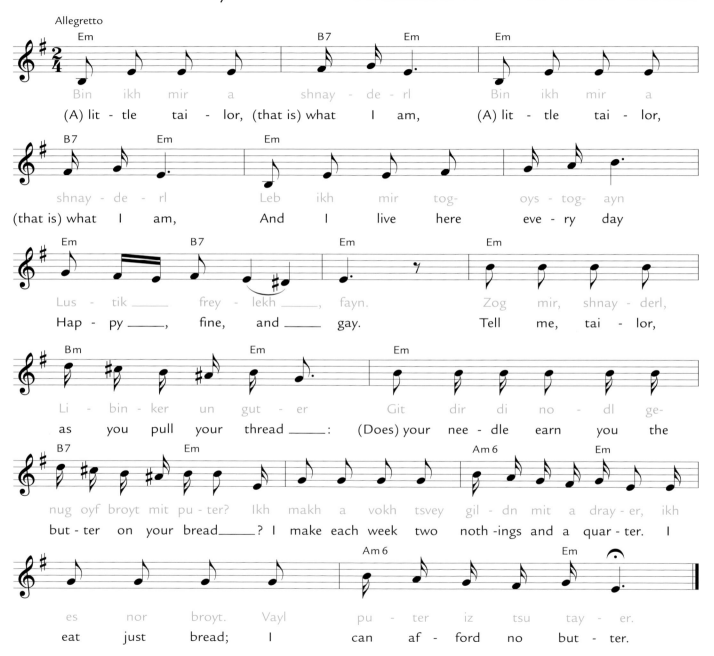

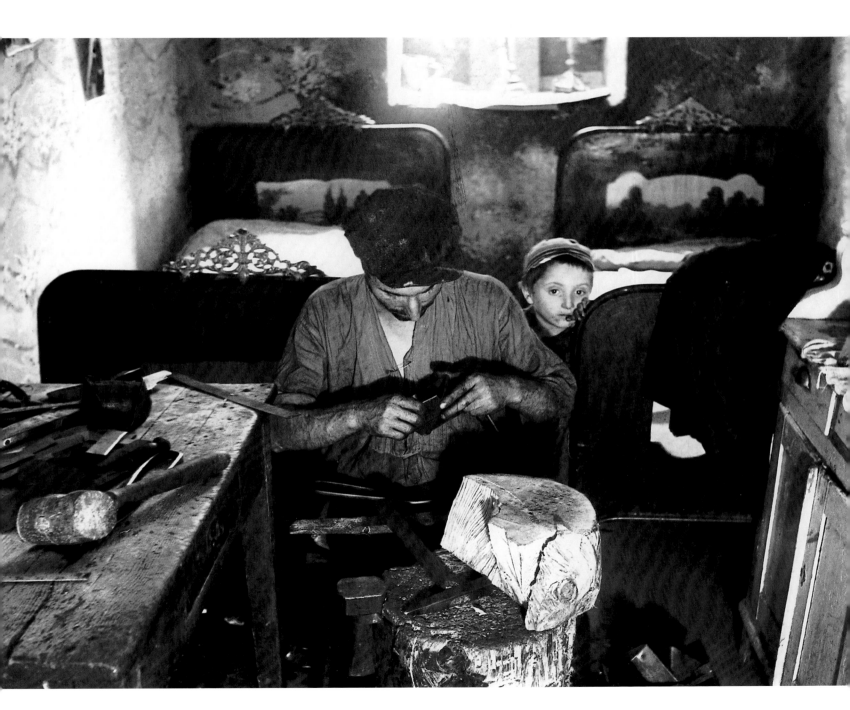

Oy, Mayn Kepele Oy, My Little Head

Oy mayn ke - pe - le tut mir vey, Oy mayn ke - pe - le
Oy, my lit - tle head, how it hurts, Oy, my lit - tle head,

tut mir vey, Oy mayn ke - pe - le, dreyt zikh vi an e - pe - le,
how it hurts, Oy, my lit - tle head, guess I should have stayed in bed

Oy mayn ke - pe - le tut mir vey.
Oy, my lit - tle head, how it hurts.

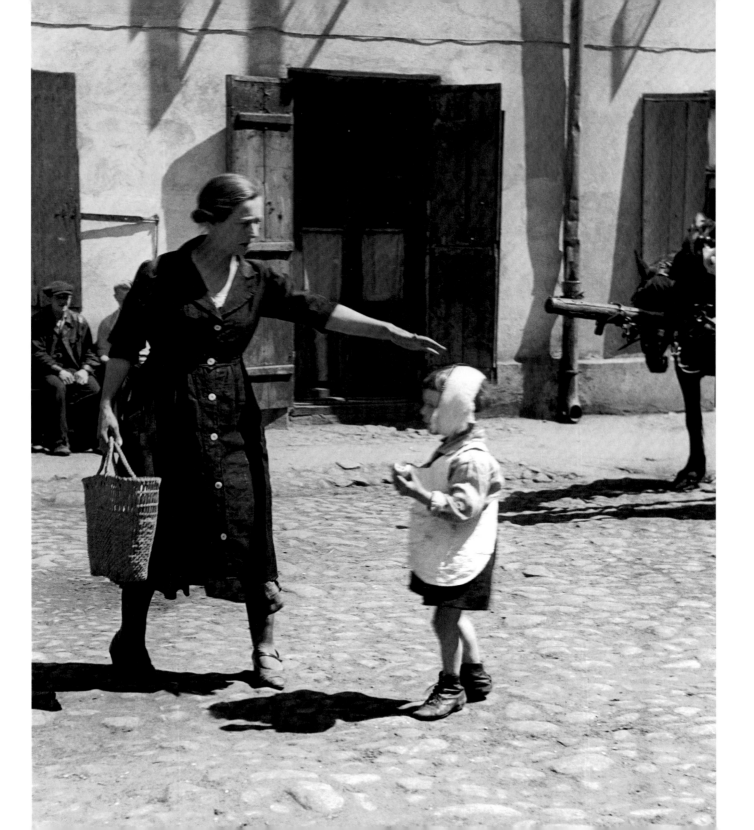

Oyfn Pripetshik On the Oven's Hearth

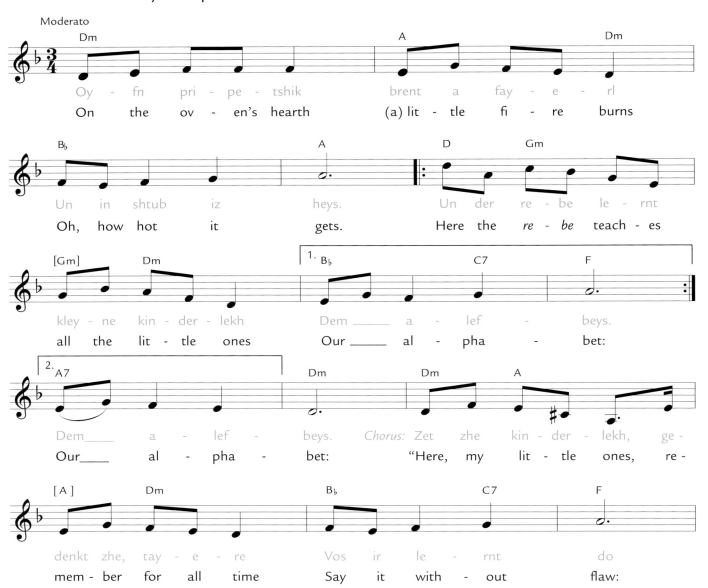

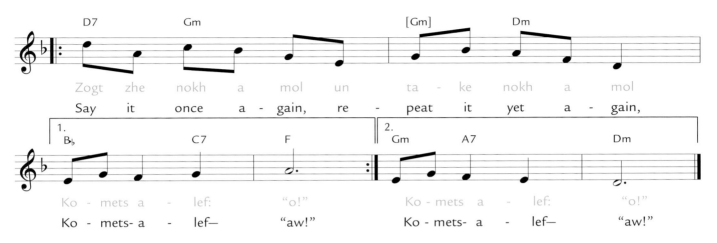

Zogt zhe nokh a mol un ta - ke nokh a mol

Say it once a - gain, re - peat it yet a - gain,

1.
Ko - mets a - lef: "o!"

Ko - mets- a - lef— "aw!"

2.
Ko - mets a - lef: "o!"

Ko - mets- a - lef— "aw!"

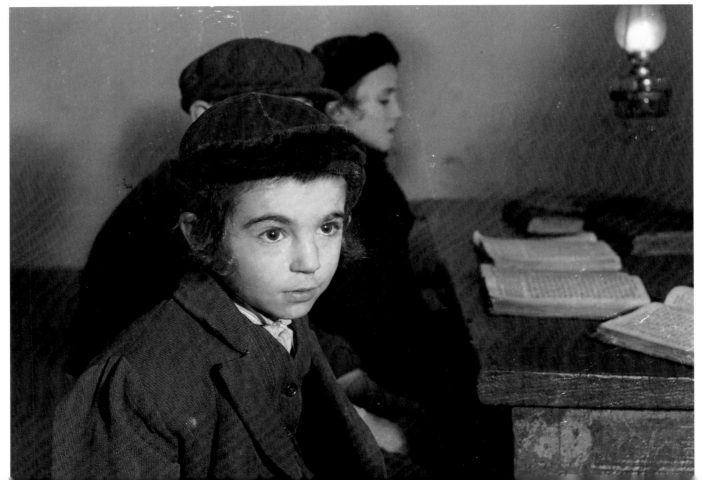

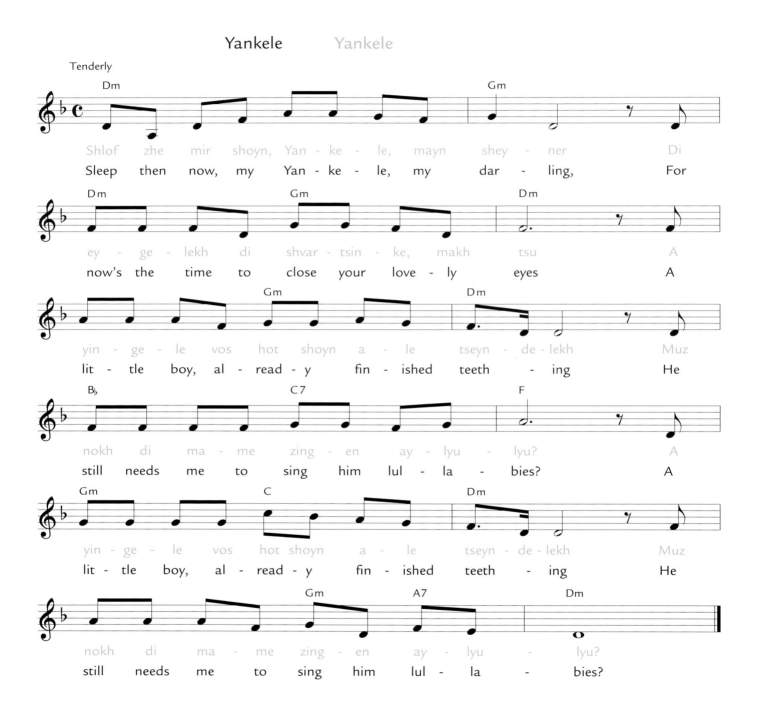

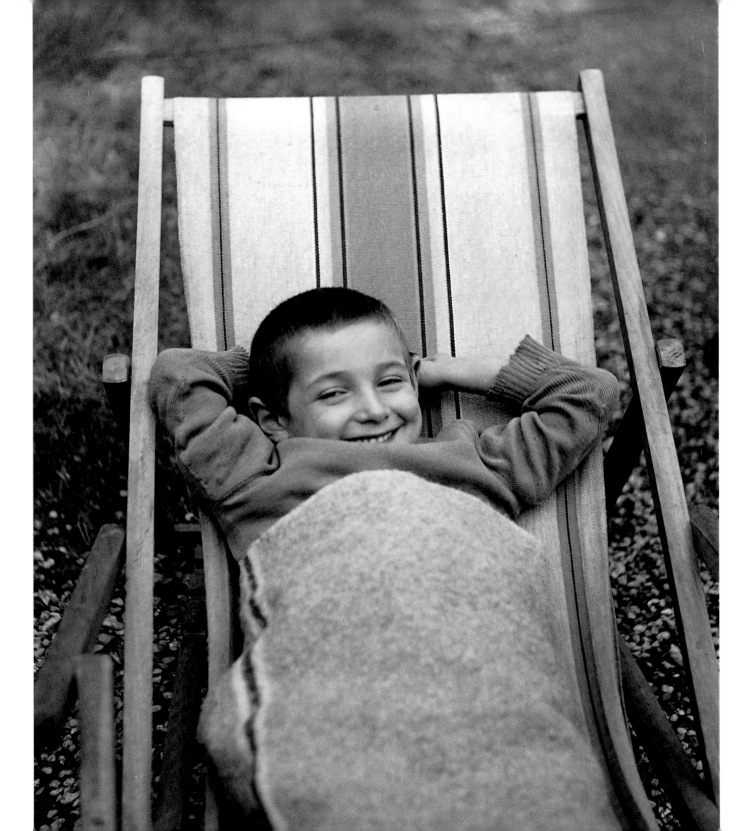

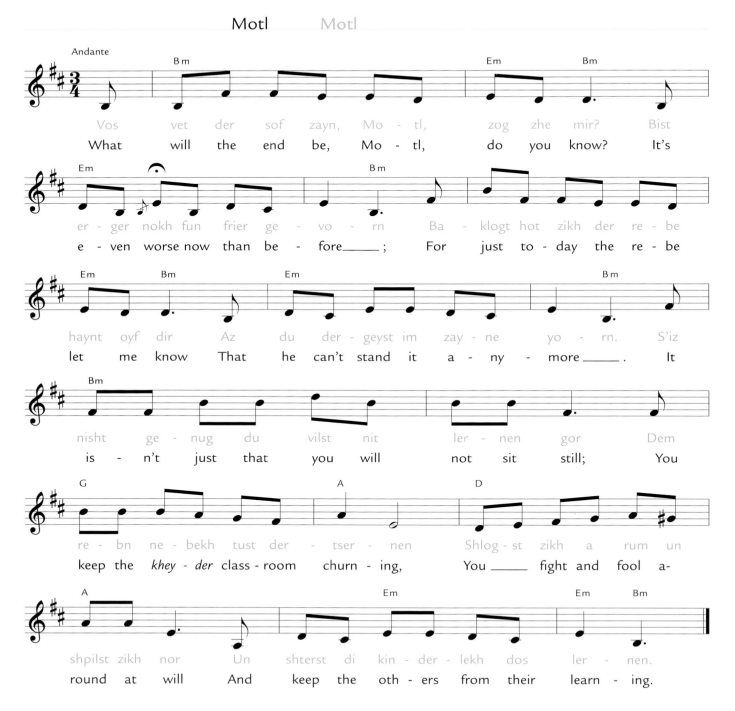

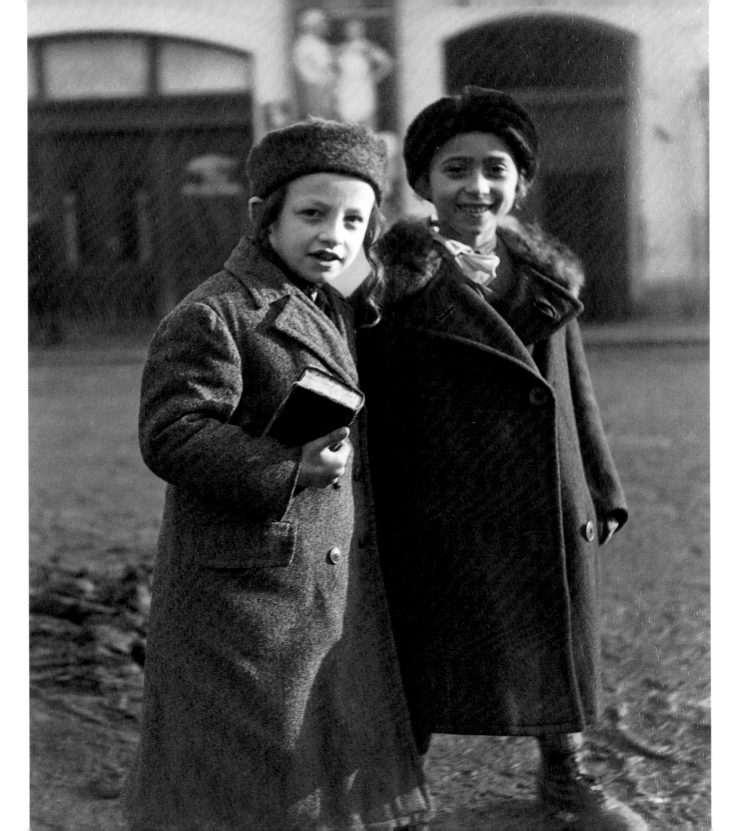

Hulyet, Kinderlekh Revel, Little Ones

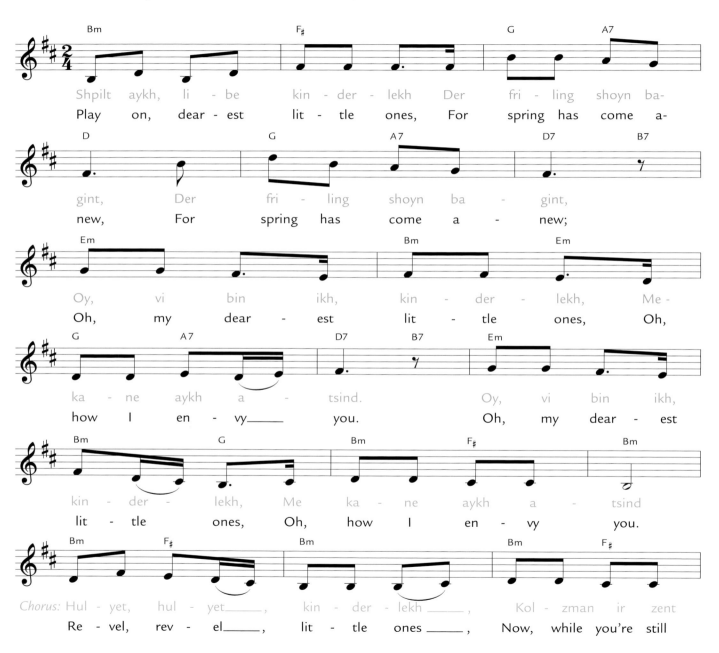

Shpilt aykh, li - be kin - der - lekh Der fri - ling shoyn ba-
Play on, dear - est lit - tle ones, For spring has come a-

gint, Der fri - ling shoyn ba - gint,
new, For spring has come a - new;

Oy, vi bin ikh, kin - der - lekh, Me -
Oh, my dear - est lit - tle ones, Oh,

ka - ne aykh a - tsind. Oy, vi bin ikh,
how I en - vy____ you. Oh, my dear - est

kin - der - lekh, Me ka - ne aykh a - tsind
lit - tle ones, Oh, how I en - vy you.

Chorus: Hul - yet, hul - yet____, kin - der - lekh ____, Kol - zman ir zent
Re - vel, rev - el____, lit - tle ones ____, Now, while you're still

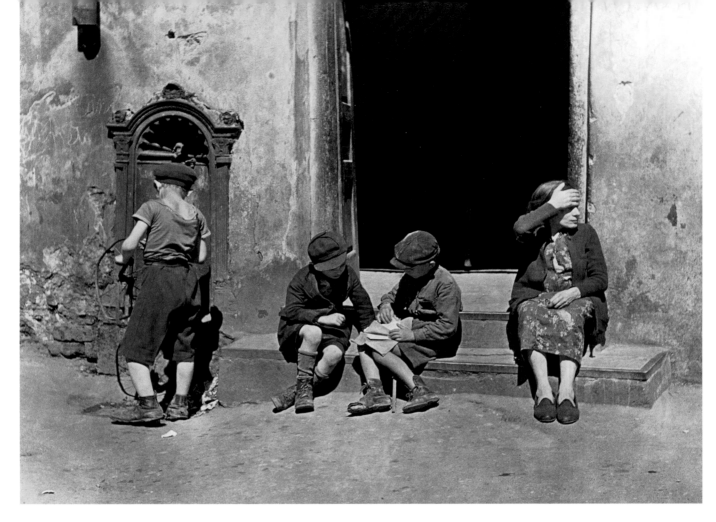

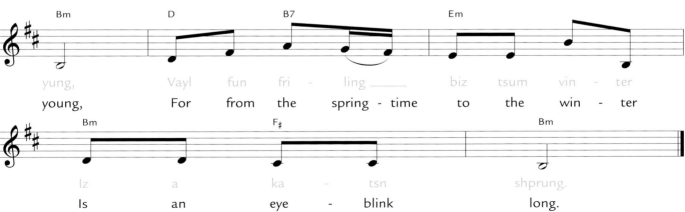

yung, Vayl fun fri - ling _____ biz tsum vin - ter

young, For from the spring - time to the win - ter

Iz a ka - tsn shprung.

Is an eye - blink long.

Dray Yingelekh Three Little Boys

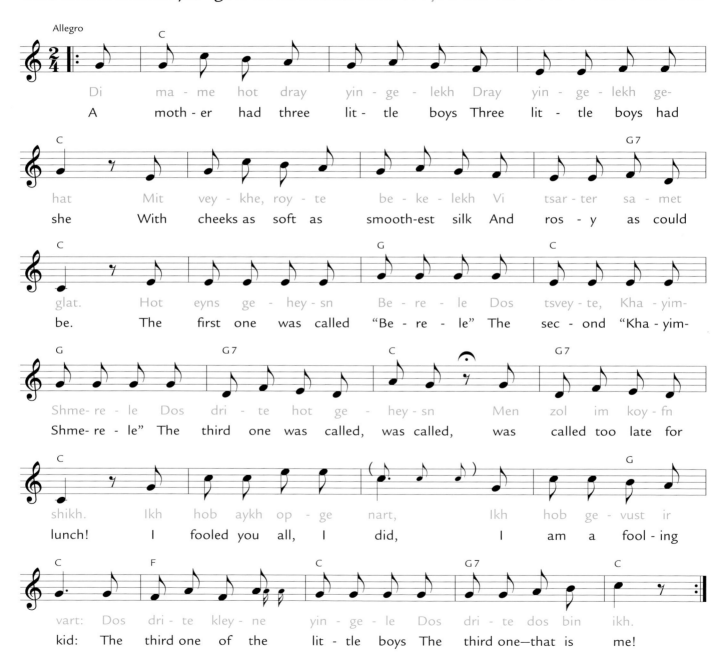

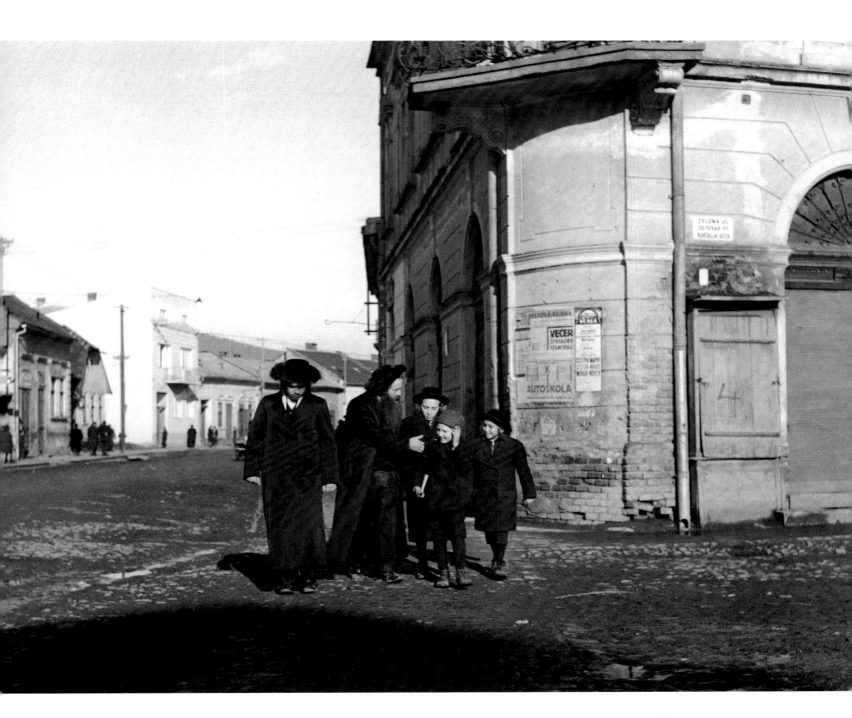

Helf Ikh Mamen Helping Mother

Moderato assae

A - le mon - tik vasht mayn ma - me, Helf ikh ma - men va - shn
Ev - ery Mon - day Moth - er wash - es, (I) help her with the wash - ing.

Helf ikh ma - men va - shn. Ot a - zoy un ot a - zoy_____
(I) help her with the wash - ing. This - a - way and that - a - way_____

Helf ikh ma - men va - shn. Ot a - zoy un
(I) help her with the wash - ing. This - a - way and

ot a - zoy_____ Helf ikh ma - men va - shn.
that - a - way_____ (I) help her with the wash - ing.

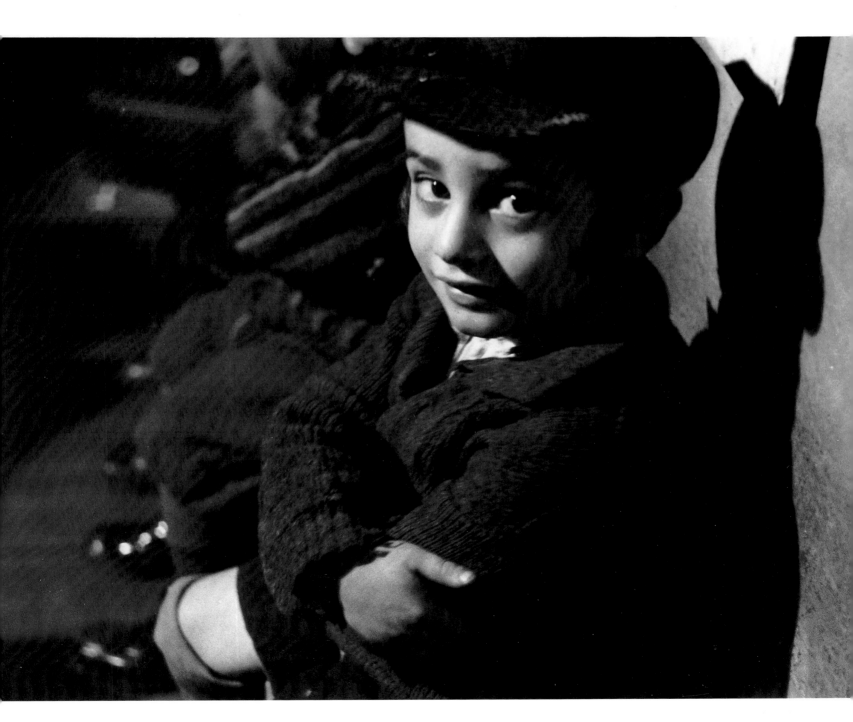

Tsu Dayn Geburtstog — Today Is Your Birthday

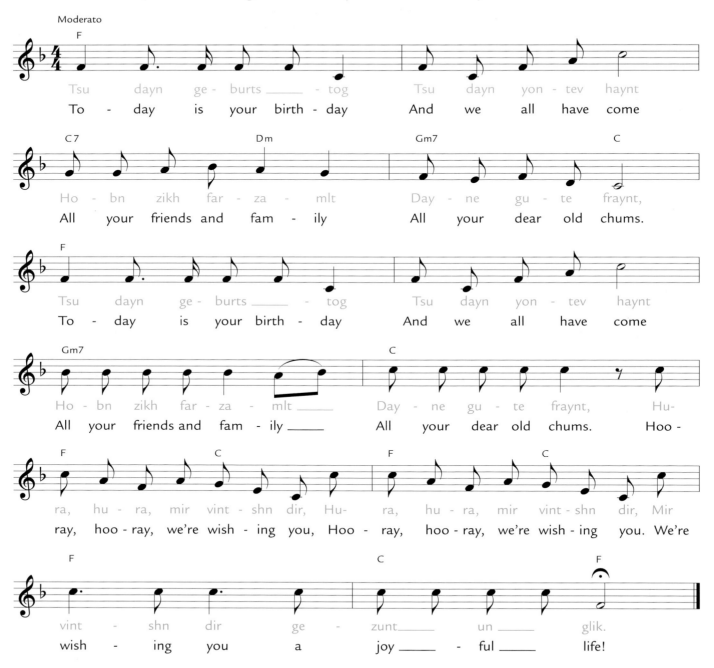

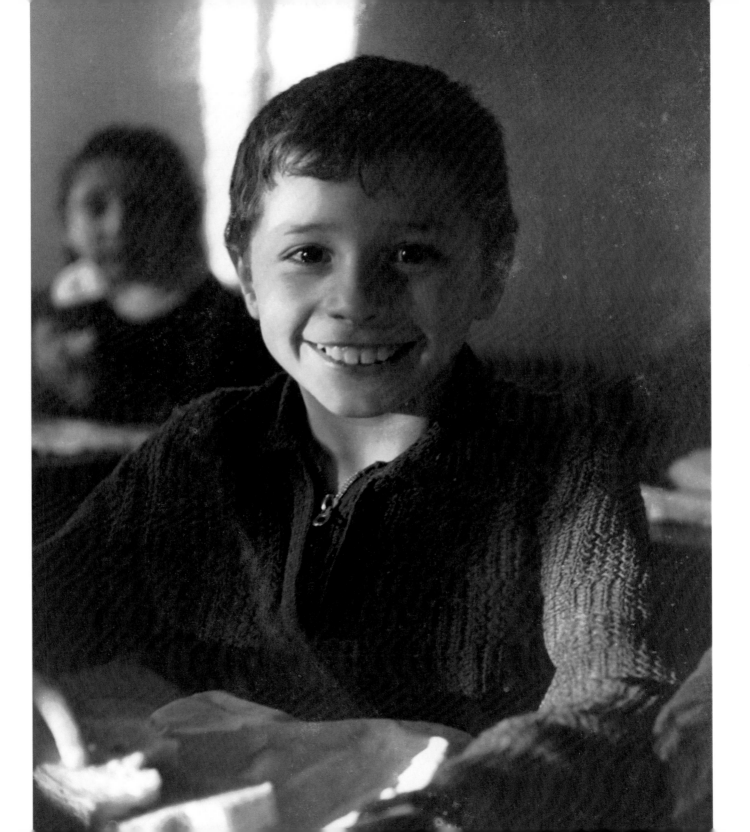

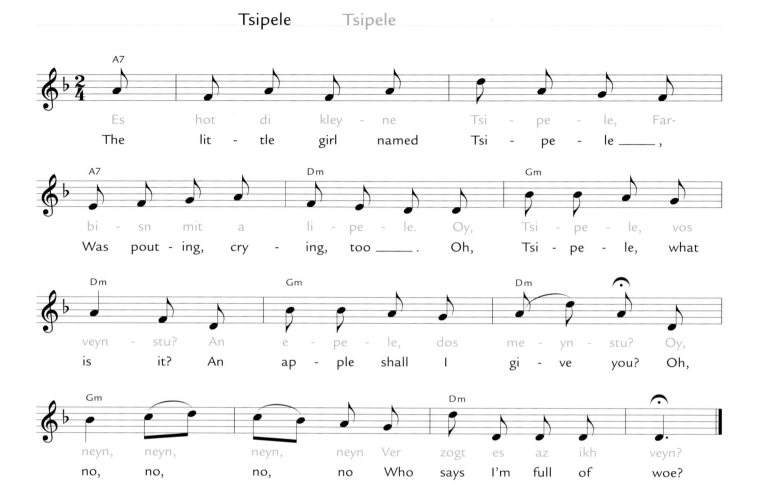

Tsipele

Es hot di kley - ne Tsi - pe - le, Far-
The lit - tle girl named Tsi - pe - le _____,

bi - sn mit a li - pe - le. Oy, Tsi - pe - le, vos
Was pout - ing, cry - ing, too _____. Oh, Tsi - pe - le, what

veyn - stu? An e - pe - le, dos me - yn - stu? Oy,
is it? An ap - ple shall I gi - ve you? Oh,

neyn, neyn, neyn, neyn Ver zogt es az ikh veyn?
no, no, no, no Who says I'm full of woe?

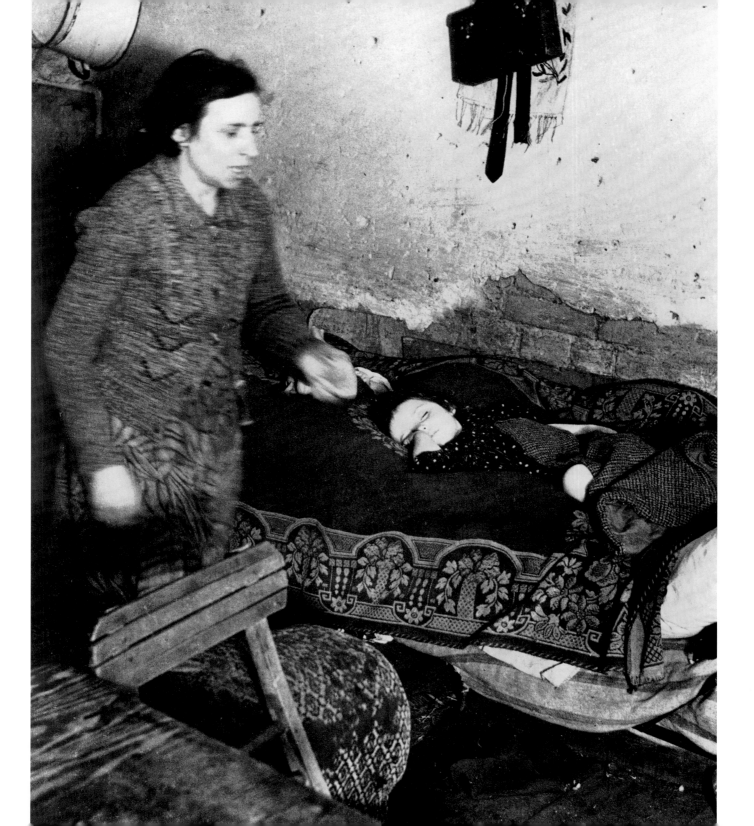

Hob Ikh Mir a Mantl I Have Me a Little Coat

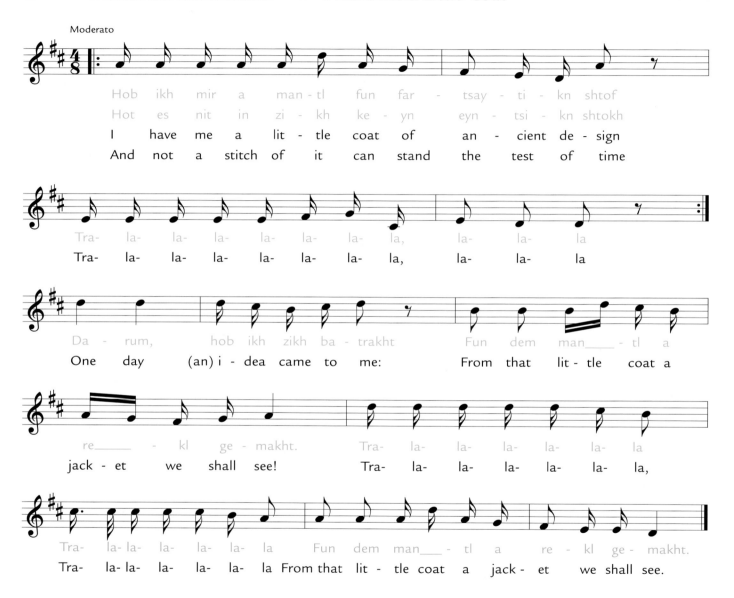

Moderato

Hob ikh mir a man-tl fun far-tsay-ti-kn shtof
Hot es nit in zi-kh ke-yn eyn-tsi-kn shtokh
I have me a lit-tle coat of an-cient de-sign
And not a stitch of it can stand the test of time

Tra-la-la-la-la-la-la-la, la-la-la
Tra-la-la-la-la-la-la-la, la-la-la

Da-rum, hob ikh zikh ba-trakht Fun dem man___-tl a
One day (an)i-dea came to me: From that lit-tle coat a

re___-kl ge-makht. Tra-la-la-la-la-la-la
jack-et we shall see! Tra-la-la-la-la-la-la,

Tra-la-la-la-la-la-la Fun dem man___-tl a re-kl ge-makht.
Tra-la-la-la-la-la-la From that lit-tle coat a jack-et we shall see.

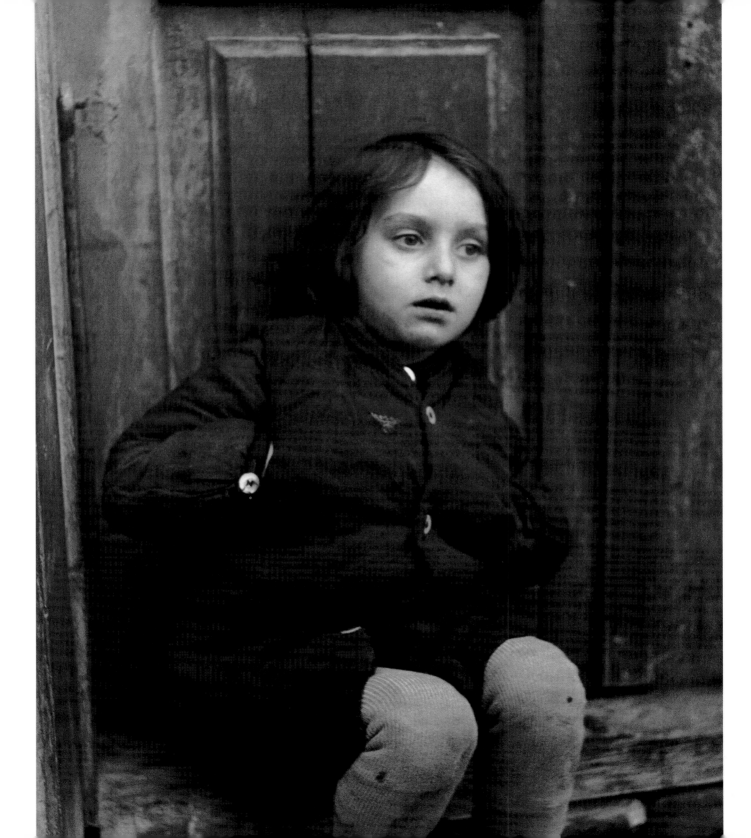

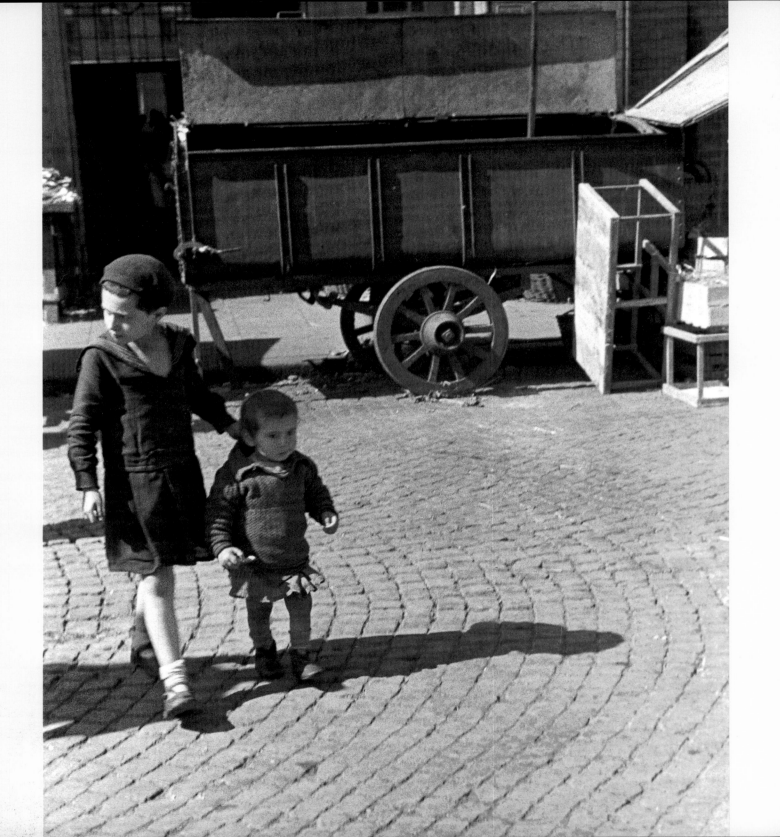

Coda: The Story of the Horse

At one point while taking these photographs of Eastern European Jews, Roman Vishniac wanted to find a small, isolated community. He spoke to many people and learned of such a place in the mountains. He decided to take three cameras and tripods, as well as other heavy equipment. But how could he carry so much? From the notes he wrote at that time, we know what happened.

The first thing he did was to ask several of his new friends if anybody had a horse he could rent. "Finally," he wrote, "I met a man who did not exactly have a horse, but had heard about one from a friend." So this man called his friend, who called another man, and that man said that, yes, he knew a man with a cart and a horse. The man he knew had not had many jobs for his horse and would probably be glad to earn some money. They went to the man's house and explained the problem with the heavy equipment. "Yes," he said, "I would be glad to have this job. But I have one serious difficulty. Lately, I have not been able to feed my horse as much as he needs, and he is hungry and not very strong. The first thing you must do is to give me enough money for food for the horse and also for the trip." Roman agreed.

On the day of the trip, the owner of the horse, who would also be its driver, helped Roman load the cart. Several times he shook his head doubtfully and said, "Heavy. Very heavy." At last they started out, and the horse seemed to pull the cart with the two

men and all the photographic equipment quite well. Gradually, as they moved into the mountains, the road got steeper. The driver told Roman that it would be better if he got out and walked, so the horse would have a lighter load. Now Roman walked behind the cart, and they went on like this for some hours. Then, the road became steeper still and the driver suggested that perhaps it would be better if Roman carried one of the tripods so that the horse would not get too tired. "And so," Roman's notes say, "we could go a little farther."

But it was hard to walk on the rocky path with that heavy tripod. And just when Roman decided he could go no farther, the horse decided the same thing. Roman reminded the driver that he had already paid for the whole job. "You're right," the driver answered, "but look at this horse. He's thin and he's tired and he is pulling a load that is too heavy. Do you want him to die right here?" And Roman saw that there was no help for it.

Together, the two men unloaded the cart and piled everything at the side of the road. Then they said good-bye, and horse and driver went off, a little faster now, down the hill. And Roman? He figured out that if he divided all the equipment into several parts he could slowly go up with one load, come down, and take another. After several trips, which took quite a long time—when he was just as tired as the horse had been—he had done it.

—Mara Vishniac Kohn

Notes

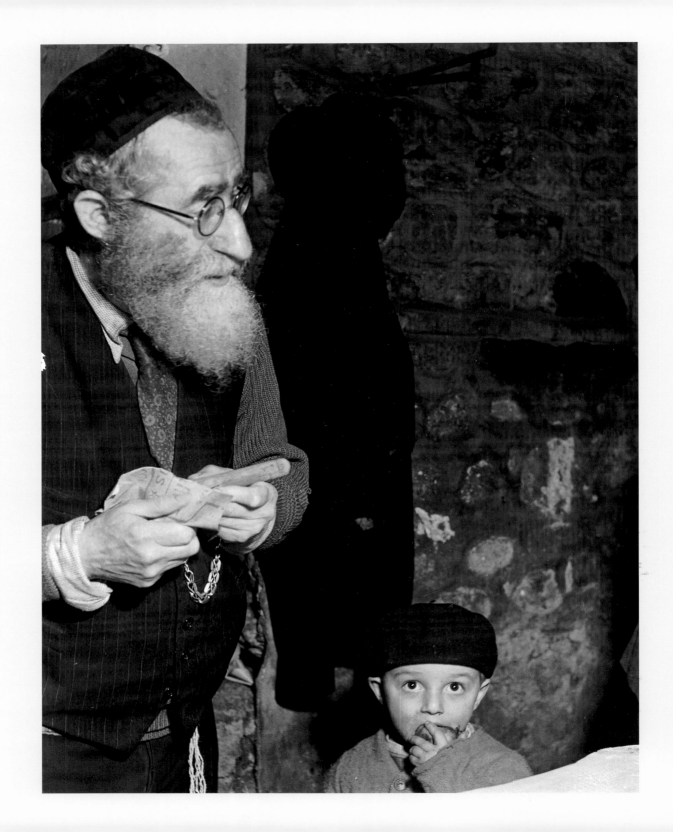

A Guide to Pronunciation

The standard system, devised by YIVO, creates a direct correspondence between the Latin letters and the sounds of standard literary Yiddish:

a	like *a* in *a*ccount
e	like *e* in g*e*t
i	like *ee* in f*ee*d
o	like *o* in d*o*g
u	like *oo* in m*oo*n
y	like *y* in *y*es
ay	like *uy* in g*uy*
ey	like *ay* in d*ay*
oy	like *oi* in t*oi*l
kh	like *ch* in *ch*utzpa or *Ch*anuka (guttural sound)
s	like *s* in *s*ad
sh	like *sh* in *sh*oe
ts	like *zz* in pi*zz*a
tsh	like *ch* in *ch*air
z	like *z* in *z*ebra

There are no silent letters; an *e* at the end of a word is a pronounced syllable.

Glossary of Yiddish Terms

gemore	the "Gemara," the part of the Talmud that comments on the Mishna
groshn	pennies (Polish)
keyn ayn-hore	literally, "may no evil eye"; usually said after praising a virtue
kheyder	a religious school for boys
khumesh	a small book for study, containing the first five books of the Bible (Pentateuch)
komets-alef	the first letter of the Hebrew alphabet (pronounced as in "aw")
kugl	a pudding
mentsh	a full human being
rebe	a religious school teacher
tokhes	underside, backside; root of the Yinglish "tushy"
Yidele	"little Jew" (used as a name in "Raisins and Almonds")

Information on the Texts

Page 10 ("Patsh Zhe Kikhelekh" / "Clap Your Little Hands"): This text is a game, usually played with a one- or two-year-old child. The player claps hands with the child, until the last line, when the child's cheeks are gently pinched.

Page 14 ("Oyfn Pripetshik" / "On the Oven's Hearth"): This immensely popular song was actually written by Mark Warshawsky (1840–1907). It has been thought of as a folk song for nearly a century. The music is the basis of the theme song from Steven Spielberg's *Schindler's List*.

Page 20 ("Yankele"): One of three songs in this book by Mordecai Gebirtig (1877–1942), a folk poet who was killed by the Nazis. His songs, sung in both Europe and America in the 1920s and 1930s, were part of the repertoire of every singer of Yiddish songs. Immediately adopted by audiences as "folk songs," they present the prevailing attitudes toward children and childhood in the Jewish Poland of this period.

Page 26 ("Motl"): Another Gebirtig song, a dialogue between father and son.

Page 38 ("Hulyet, Kinderlekh" / "Revel, Little Ones"): Another Gebirtig song.

Page 50 ("Rozhinkes mit Mandlen" / "Raisins and Almonds"): This is *the* Yiddish lullaby. The verse was written by Abraham Goldfaden (1840–1908), the nineteenth-century creator of Yiddish musical theater pieces. It is meant to symbolize all Jewish lullabies, all Jewish mothers, all Jewish children.

Page 62 ("Tsu Dayn Gerburtstog" / "Today Is Your Birthday"): Another piece by Goldfaden.

Page 76 ("Mame un Kind" / "Mother and Child"): A poem by Itskhok Leyb Peretz (1851–1915), writer, moralist, and the intellectual father of modern Yiddish literature. He wrote many pieces for children, and this poem appeared in a Yiddish children's magazine, *Grine Bletlekh (Little Green Leaves)*.

Pages 82–100 ("Eyns—A Nisl" / "One—A Nut" and so on): These selections are from a collection of children's rhymes and games, originally put together in 1912 by I. L. Cahan and reprinted by YIVO in 1957, in a work edited by Max Weinreich.

Page 94 ("Beys, a Shtibele" / *Beys*— A Little House"): This mnemonic for Hebrew and Polish vocabulary was helpful for the dual schooling many Jewish children were exposed to. The first italicized words are Hebrew, the second are the Polish versions, and in between are the English meanings.

Page 96 ("Lashinke, Vaysinke" / "Little Boy, Little Boy"): A Yiddish version of the Russian folk song, which was the basis for Pete Seeger's "Where Have All the Flowers Gone?"

A Note on the Translations and Music

These poems and songs are meant to be read or sung aloud. The translations therefore attempt to provide rhyme and meter for reciting or singing. Consequently, sometimes the literalness of the translation of the text must be sacrificed to the rhyme or meter. We hope that the deeper meaning and the flavor of the original are nevertheless preserved.

The musical notation will usually correspond with the meter (i.e., one syllable, one note). Occasionally, however, there will be an extra English syllable. Those syllables are printed in parentheses in the musical notation; they should, however, be sung, using the note immediately following them.

A Note on the Photographs

Roman Vishniac recorded a few notes about his images of Jewish families in Eastern Europe, but his comments were often very general: "Mother and Child," without any specific details. About Selma on page 91, he tells us, "She was sent to the store for a pot of soup and a bottle of milk." Only years later did he add that he recalled photographing her in Lodz, probably in 1939. Although a few of the prints are marked with their locations—"Community kitchen in Prague, 1937" for page 51—most are not. We know that the image on page 81 comes from Warsaw and that opposite the title page from Lodz in 1938. But for the most part the exact locations cannot be identified with any certainty. Perhaps Roman Vishniac wanted us to think deeply about the lives of the people, not their towns.

Acknowledgments

We owe many heartfelt thanks to friends and to those who, through their work, have become friends: Dina Abramowicz and the YIVO staff, Arnold Band, Walter Bierer, James Fraser, Frank Goad, Hans Guggenheim, our Yiddish reader, Janet Haddad, Anne Roiphe, Benjamin Schiff, and our favorite editors, Stanley Holwitz and Sue Heinemann. This book owes its existence in large part to its designers, Randall Goodall and Naomi Schiff. We thank most particularly our husbands, Richard Flacks and Walter Kohn, for their long-lasting encouragement and support.

Index of Texts and Music

DESIGNER: SEVENTEENTH STREET STUDIOS

COMPOSITOR: SEVENTEENTH STREET STUDIOS

WITH PETER MANSEAU (YIDDISH)

AND ERNIE MANSFIELD (MUSIC)

TYPE: ITC LEGACY SANS & QUARK FRANK

PRINTER: EUROGRAFICA

BINDER: EUROGRAFICA